IMAGES of America
AFRICAN AMERICANS OF PETERSBURG

Petersburg, Virginia, is located 25 miles south of Richmond, the capital of the commonwealth, and has a population of approximately 32,000. Established in 1748, Petersburg grew out of the tobacco trade system. Its location on the Appomattox River helped it garner status as a tobacco inspection site and made it a regional center for tobacco shipping and production and for the production of other goods. As the profitability of tobacco rose, so did the fortunes of Petersburg. The construction of railroads in Petersburg connecting cities and counties in the South with locations to the north enabled the city grow in size and commercial importance, rivaling and at times surpassing that of Richmond. (Courtesy of Russell Wayne Davis.)

ON THE COVER: On October 18, 1948, Petersburg photographer William E. Lum took this picture of two soldiers entering Petersburg's USO Club on Byrne Street, the present-day location of the Beaux Twenty Club, Inc. (Courtesy of the City of Petersburg Museums.)

IMAGES of America
AFRICAN AMERICANS OF PETERSBURG

Amina Luqman-Dawson

Copyright © 2008 by Amina Luqman-Dawson
ISBN 978-0-7385-5414-3

Published by Arcadia Publishing
Charleston, South Carolina

Printed in the United States of America

Library of Congress Catalog Card Number: Applied for.

For all general information contact Arcadia Publishing at:
Telephone 843-853-2070
Fax 843-853-0044
E-mail sales@arcadiapublishing.com
For customer service and orders:
Toll-Free 1-888-313-2665

Visit us on the Internet at www.arcadiapublishing.com

To Robert.

To our darling newborn son, Zach. May this book one day inspire you to push through your fears and follow your heart.

Contents

Acknowledgments		6
Introduction		7
1.	Faces of the Early Years	9
2.	In Service of Country	23
3.	A City of Churches	35
4.	The Struggle for Equality	51
5.	A New Day in Politics	65
6.	The Heyday of Black Business	77
7.	The Power of Knowledge	93
8.	In Service of Community	105
9.	People and Places of Note	119

ACKNOWLEDGMENTS

Thanks to Wayne Crocker, the City of Petersburg's director of library services, for your assistance and for use of library equipment and facilities.

I was fortunate to have found kind spirits and champions in Petersburg who provided images or assistance in locating images; those who have shared their wisdom and knowledge about Petersburg's African American community; and others who have pointed me in the direction of resources and people to help move the project forward. For this, I offer my greatest appreciation to truly helpful and kindred spirits Iris Brown; Ranger Robert Webster of the Petersburg National Battlefield; Thomasine Burke of Gillfield Baptist Church; Peggy Lee of First Baptist Church; Dr. Florence Farley; Russell Wayne Davis; Dr. Margaret Crowder Johnson; Col. Porcher and Ann Taylor; Rev. Dr. Wyatt Tee Walker and his wife, Ann Walker; Herbert Coulton; Ruth Maclin and family; Mattie Watson Powell; Juanita Owens-Wyatt; Rose Muse; R. J. Bragg; Ernest Shaw; Betty Nunnally; Sandra Walker; Lillian Pride Smith; Dr. Foster Miles; William Wyche Jr; and Samuel Batts.

Thanks as well for the invaluable assistance of Petersburg's African American churches; the City of Petersburg Museums, in particular to curator of collections Laura Willoughby and collection assistant Doug Harris; Luther Hansen of the Quartermaster Museum at Fort Lee; Brian Couturier of the Petersburg *Progress-Index*; and the *Richmond Times Dispatch*.

Thanks to Elvatrice Belsches for believing that I could do this project.

I thank my family for your love and support: my mom for your support; Alia for your ear to listen; Muhammad for your technical expertise; and Khadijah for your belief in the project and for your assistance.

And I am grateful to my dear husband, Robert, for planting the idea for this project in my head, for always believing in my abilities, and for loving and supporting me in every way through this process. You are truly a gift in my life.

INTRODUCTION

The following chapters paint a prideful picture of African American life in Petersburg. These photographs and the stories they tell illuminate a poignant idea that regardless of class, educational achievement, church affiliation, or club membership, African Americans in Petersburg comprise a single community that is bound together by a rich history of supporting one another to ensure the success of the whole, of triumph in the face of adversity, and of daring to strive for a better tomorrow.

Given the nuances and complexity of Petersburg's rich African American history, this book is not intended to provide a comprehensive historical archive, but rather to document and give face and form to many of the precious memories held and stories told by Petersburg's African American residents. It is essentially a community album of photographs, postcards, and images of people and moments that fill the community with pride.

Although some of the images are from museums and libraries, the book is primarily a compilation of cherished photographs from the mantles and photo albums from people's homes and the heritage rooms of Petersburg's black churches. These are the faces of the individuals that inspire a community to push forward and remind a community of its strength. This is a celebration not only of the most extraordinary moments or people who received the most praise, but also of what happens when ordinary people do extraordinary things to achieve what may seem unthinkable.

Each of the nine chapters is a view into the incredible events, people, and places that make Petersburg a treasure in the history of Africans in America. It begins with the earliest years of African American life in Petersburg. These images depict a variety of people who lived and thrived in extraordinarily challenging times. The chapter on military life illuminates the fact that more African American soldiers participated in the Siege of Petersburg than in any other Civil War engagement. In the chapter on churches the images are a journey through Petersburg's oldest black churches, including First Baptist Church on Harrison Street, believed to be the nation's oldest black Baptist church. The book continues with a portrait of the courageous residents of Petersburg who participated in the civil rights movement, from famous civil rights leader Rev. Wyatt Tee Walker to the city's young people who courageously desegregated the city library and lunch counters. In the chapter on politics, we see the fruits of the civil rights movement, where a mobilized black community elected the first black mayor and majority black city council in Virginia. Finally the book highlights people and places in education, business, and civic life, from the first black public high school in Virginia (and possibly in the nation) to some of the oldest black civic organizations in the South.

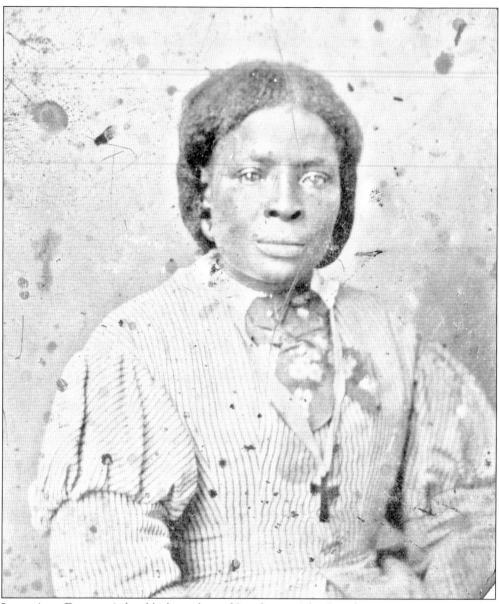

LUCY ANN FISHER. A free black resident of Pocahontas Island in the 1800s, Lucy Ann Fisher was born in 1822. Census records show that Fisher could read and worked in the local tobacco factory. She was also a well-respected leader in the Pocahontas community. On August 18, 1866, the New York Freedmen's Relief Society deeded the land and building that became the Pocahontas Chapel to her and her husband, Jack Fisher. (Courtesy of Alice Butcher Jones and family.)

One

FACES OF THE EARLY YEARS

Although it is unclear when the first African Americans arrived in Petersburg, evidence of their presence dates as far back as the 1600s, when most arrived as indentured servants or were enslaved. Some of these early arrivals completed their terms of indenture, others earned their freedom (particularly during times when tobacco farming became less lucrative), and others later gained manumission during the equalitarian movement following the Revolutionary War or by having served in the war. By 1830, approximately one third of the total African American population of Petersburg was considered "free persons of color." By the Civil War, Petersburg had the largest population of free blacks of any city in Virginia. According to the 1850 census, there were 2,616 free blacks in Petersburg, 245 more than in Richmond. By 1860, the number of free blacks in Petersburg increased to 3,244, one third of whom owned property. They resided in old, historically black neighborhoods of the city including Pocahontas Island and Blandford.

Even with their free status, however, state laws and local ordinances were often enacted to restrict many aspects of their lives. A free black person was not permitted to vote, sit on a jury, or even travel from one county to another without permission. Despite these obstacles, free blacks in Petersburg created communities to help insulate themselves from repressive laws, pool their resources, and exercise their freedom and independence. They were the tobacco warehouse laborers, mail carriers, train porters, and small business owners of their day, who quietly succeeded amidst incredible odds.

The following images are intended to paint a picture of everyday life in Petersburg's early black community and to give face and form to ordinary people who lived and thrived during extraordinary times.

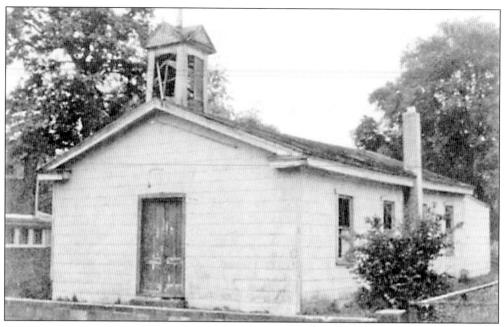

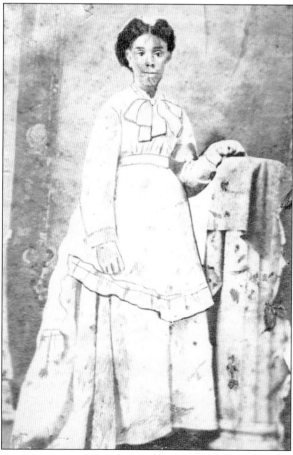

POCAHONTAS CHAPEL. The Pocahontas chapel was originally the temporary headquarters for Gen. Ulysses S. Grant during the Civil War. Jack Fisher and Lucian Fisher of Pocahontas Island built a barge to transport the building from City Point to the island. The chapel became the heart of religious and social life on Pocahontas and served as a school and the community's center for decades to follow. (Courtesy of the City of Petersburg.)

REBECCA FISHER MASON. The daughter of Lucy Ann Fisher, Rebecca was born free in 1855 and resided on Pocahontas Island. She could read and write and was known as a bible scholar. A member of Sandy Beach Church, she participated in the church's move from Pocahontas to Gill's Field, the sight of the present-day Gillfield Baptist Church. She is said to have assisted in the construction of Gillfield Baptist Church by carrying bricks on her head to the church's construction site. (Courtesy of Alice Butcher Jones and family.)

THE BUTCHER FAMILY. The Butcher family was among the many landowners who resided on Pocahontas Island. Pictured here are a mother and two sons; from left to right are James Butcher, Agnes T. Butcher, and Joseph Butcher. Joseph Butcher was born in 1869 and worked in a local factory. He enlisted in the military during the Spanish-American War and was later known for selling homemade candies. Agnes Butcher was born in 1852, worked as a factory hand, was a property owner, and was known as a money saver. (Courtesy of Alice Butcher Jones and family.)

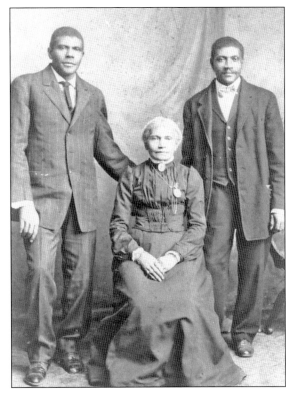

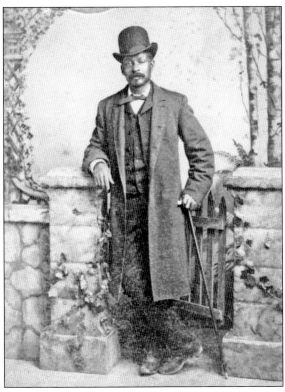

MAJOR DUNCAN. Born in the 1870, Duncan was a landowner on Pocahontas Island at 139 Main Street. (Courtesy of Alice Butcher Jones and family.)

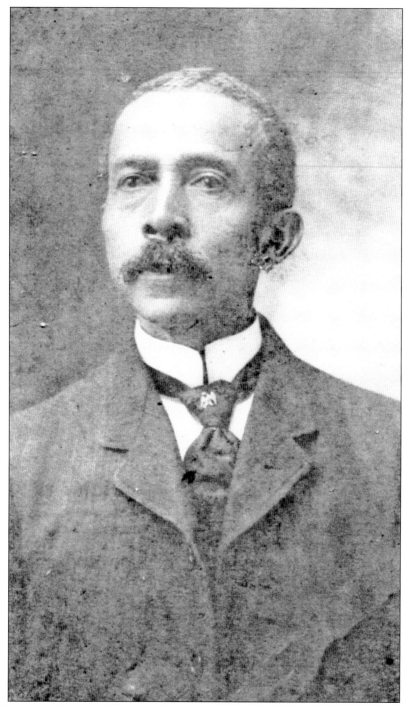

JAMES MEREDITH BOLLING HOLMES. Born in 1844, Meredith was Petersburg's first African American mail carrier. He was a prosperous landowner. Holmes owned five houses on Guarantee Street, all said to have been fitted with indoor plumbing and electric lights. Holmes resided in one of the homes with his wife, Mary Jane Holmes. A member of Second Presbyterian Baptist Church on West Washington Stree, he died in 1923. (Courtesy of Nathaniel Dance Jr.)

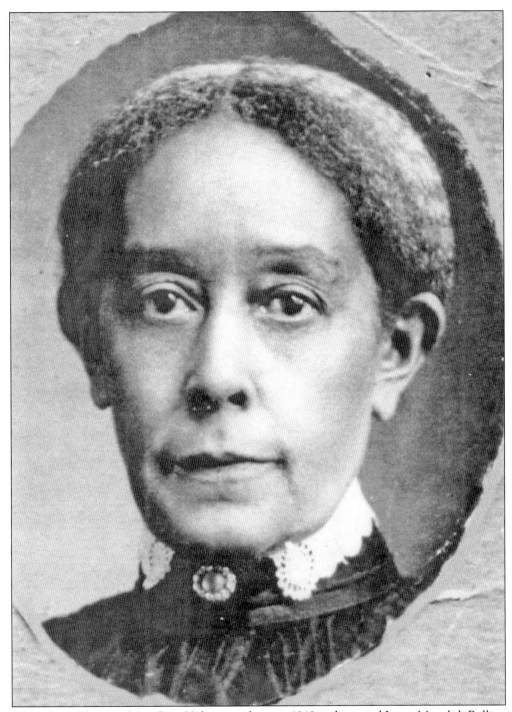

MARY JANE HOLMES. Mary Jane Holmes was born in 1848 and married James Meredith Bolling Holmes. Her mother, Fannie Strong, was born enslaved in Farmville. It is said that when Fannie Strong came to live with her daughter in Petersburg, she looked at herself in front of a household mirror in amazement. She had never seen her own reflection. (Courtesy of Nathaniel Dance Jr.)

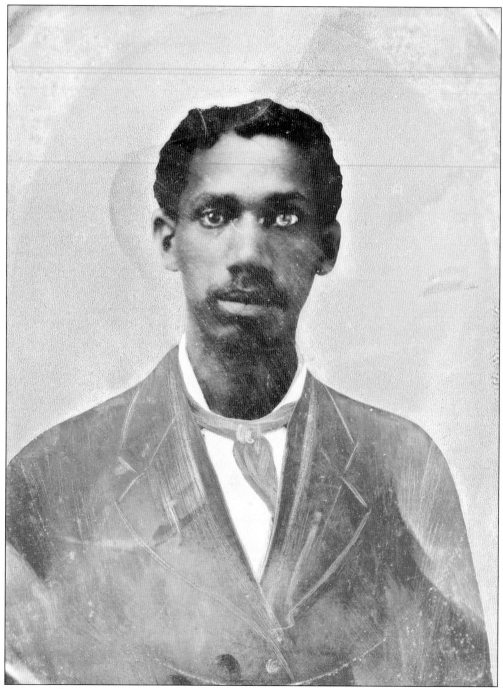

WILLIAM CROWDER. Crowder was born in 1855 and was a resident of the Blandford area at 409 Miller Street. Census records show Crowder was employed as a mail carrier for the City of Petersburg. (Courtesy of Dr. Margaret Crowder Johnson.)

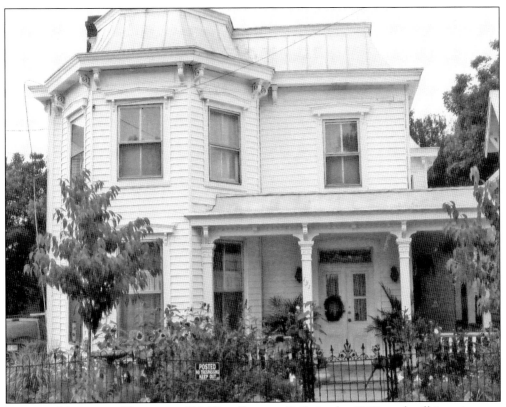

DUNBAR MEMORIAL HOSPITAL, 131 NEW STREET. Built in the 1890s and still in existence, 131 New Street served as a hospital for African Americans in Petersburg in the early 1900s. This photograph was taken in 2008. (Courtesy of Amina Luqman-Dawson.)

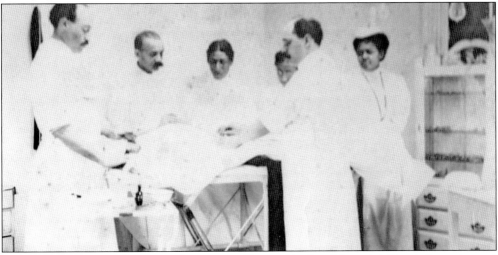

DUNBAR MEMORIAL HOSPITAL OPERATING ROOM. Dunbar Memorial Hospital was located at 131 New Street. This early-1900s image was taken of doctors and nurses in the hospital's operating room. Pictured from left clockwise around the surgery table are Dr. McCoy, Dr. Clarke, Dr. Crowder, Mrs. Mason, Miss Carter, and Dr. Alexander. (Courtesy of Dr. Margaret Crowder Johnson.)

[Free papers document for Emily C. A. Crowder, State of Virginia, City of Petersburg, dated February 25, 1858.]

FREE PAPERS. Prior to the Civil War's end, free blacks were required to carry documentation to prove their freedom. These valuable "free papers" often described physical features and identifying marks. Shown are free papers for Emily Crowder, a resident of the Blandford community in 1858. Crowder is described as being 25 years old, of a light complexion, and having a scar on her right wrist. (Courtesy of Dr. Margaret Crowder Johnson.)

ALBERT JONES I. Jones resided on Pocahontas Island at 216 Witten Street. For several years, he worked as a porter for the Norfolk and Western Railroad Company. He married Alice Thompson, a student at Virginia Normal and Collegiate Institute and native of Saratoga, New York. This image was taken of Jones in the early 1900s. (Courtesy of Bessie Jones.)

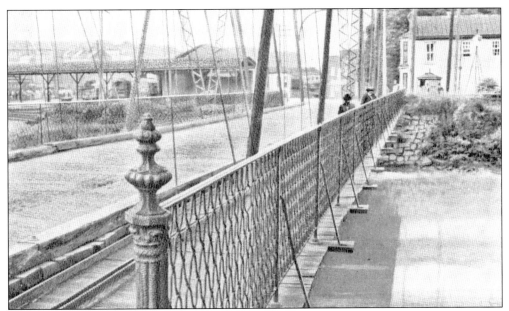

POCAHONTAS BRIDGE. Pocahontas Bridge, pictured here, was first constructed in 1752. It was destroyed during the Revolutionary War and was later rebuit. The bridge further incorporated Pocahontas into the commerce and trade of Petersburg and brought new residents. In 1784, Pocahontas was incorporated as part of the city of Petersburg. (Courtesy of Russell Wayne Davis.)

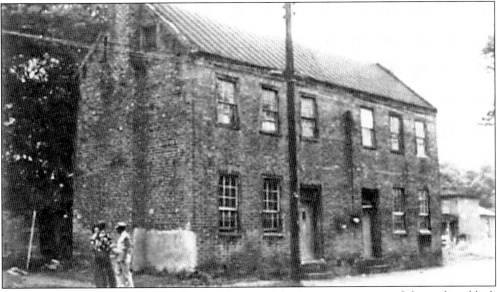

THE JARRATT HOUSE, 808–810 LOGAN STREET. The Jarratts were one of the earliest black families to locate on Pocahontas Island. Richard Jarrett was a resident of Pocahontas Island and engaged in the fishing and carrying trade in the early 1800s. He was prosperous in his work and became a leader in the community, helping to found Sandy Beach Church, which later became Gillfield Baptist Church. The Jarrett House was built around 1820 by John Wilder and was sold to the Jarrett family in 1879. It is the oldest dwelling on Pocahontas Island. (Courtesy of the Petersburg Museum Collection.)

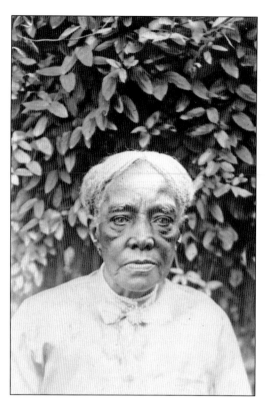

LUCINDA JARRATT HARE. Family research indicates that Lucinda Jarratt Hare, born in 1833, was the granddaughter of the notable fishing and carrying tradesman Richard Jarratt. Hare lived on Pocahontas Island and was the mother of Margaret Hare Penn and Mary Hare. (Courtesy of Virginius and Lottie Bragg.)

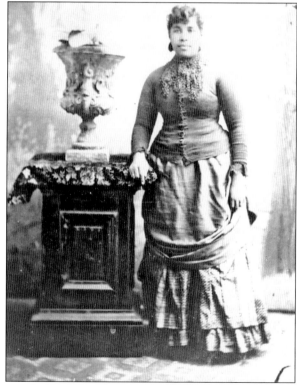

MARGARET HARE PENN. Margaret Hare Penn was the daughter of Lucinda Jarratt Hare and the great-granddaughter of Richard Jarratt. She lived on the Jarratt family plot at 210 Rolfe Street with her husband, Robert Penn. (Courtesy of Virginius and Lottie Bragg.)

MARY HARE. Mary Hare, daughter of Lucinda Jarratt Hare and great-granddaughter of Richard Jarratt, was educated at the Virginia Normal and Collegiate Institute. She was a resident of Pocahontas Island, but her work took her to Washington, D.C., where she served as a cook for a Republican U.S. senator from West Virginia, Nathaniel Goff. (Courtesy of Virginius and Lottie Bragg.)

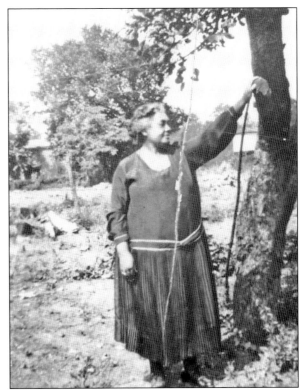

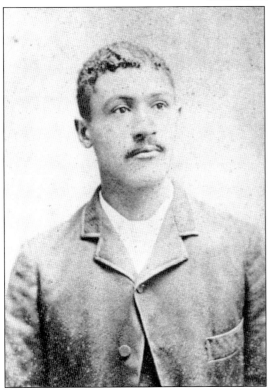

WILLIAM A. PENN. Penn was an architect and builder and lived at 1011 Wilcox Street. He constructed the first Mount Olivet Baptist Church building around 1901. Penn died in 1932. (Courtesy of Mount Olivet Baptist Church.)

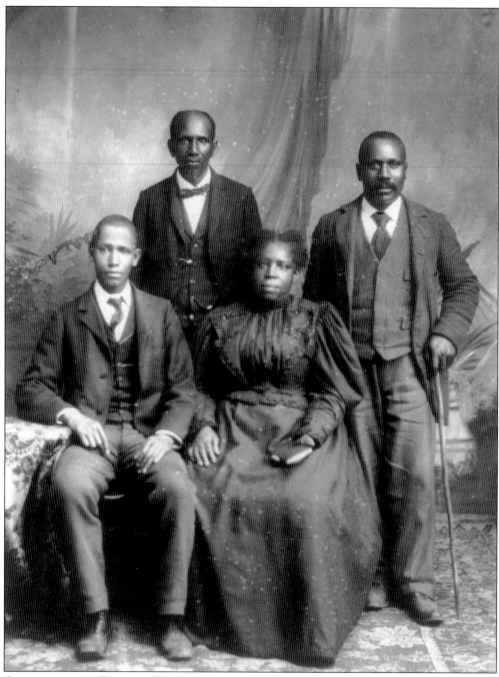

OFFICERS OF THE TOBACCO TRADE UNION, C. 1900. The union was an important organizing tool for tobacco laborers at the beginning of the 20th century. This image of Petersburg tobacco trade union officers was reportedly displayed as part of the American Negro Exhibit at the Paris Exposition of 1900. (Courtesy of the Library of Congress.)

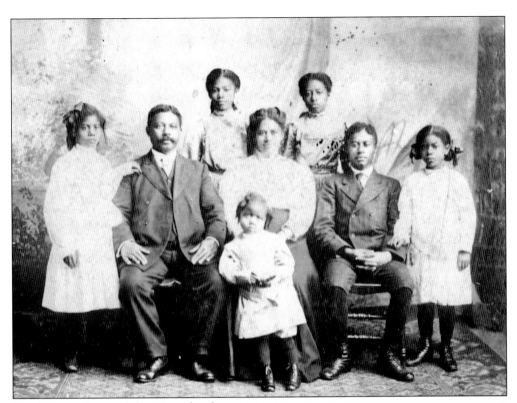

THE WYATT FAMILY. The Wyatt family is, from left to right, (first row) Charles Wyatt; (second row) Harriet Wyatt, Waverly Wyatt Sr. (father), Mary Wyatt (mother), Waverly Westwood Wyatt Jr., and Marion Wyatt; (third row) Julia Wyatt and Ella Wyatt. This image was taken around 1910. Julia Wyatt went on to teach at Peabody High School and authored the school's song. (Courtesy of Juanita Owens Wyatt.)

THE BROWN FAMILY. The Brown family lived at 1342 Rome Street. Thomas H. Brown (seated) and his wife, Ellen Brown (seated), were both born in 1874. Thomas Brown was an undertaker and longtime caretaker of the historic People's Cemetery of Petersburg. They are pictured here with their daughter Julia Brown Burke (standing). (Courtesy of Thomasine Burke.)

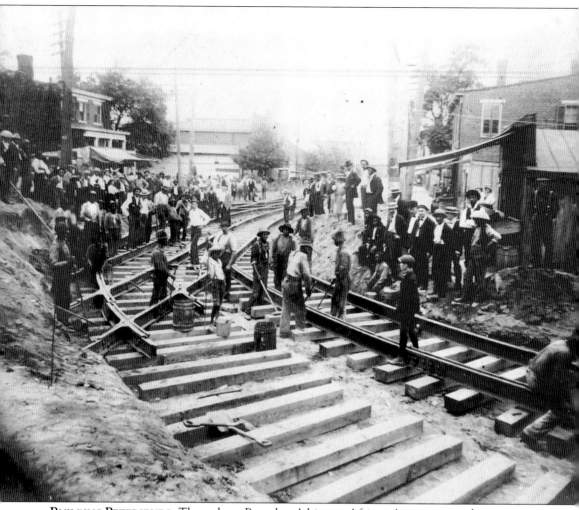

BUILDING PETERSBURG. Throughout Petersburg's history, African Americans made an immense contribution to constructing the city's infrastructure and buildings. Here, in 1899, black workers lay tracks for a city trolley line to run along Sycamore Street into the city's downtown. (Courtesy of Russell Wayne Davis.)

Two

IN SERVICE OF COUNTRY

Each year, visitors from across the nation arrive in Petersburg to experience a piece of Civil War history. Battles and events occurred here that shaped the war's outcome and the nation's future. Woven into this military history is the valuable contribution of African American soldiers known as United States Colored Troops or USCT.

At the time of the Civil War, Petersburg was the second largest city in Virginia and a vital location for the transportation of needed supplies to Confederate troops. After failing to capture Petersburg by frontal attack in 1864, Gen. Ulysses S. Grant and the Union army settled in for what would become a yearlong siege of the city.

Twenty-two USCT regiments participated in the Siege of Petersburg, more than in any other military engagement during the Civil War. These soldiers were free blacks from the North and the South, but most commonly, they were enslaved blacks who joined the military for their freedom and the freedom of four million other slaves.

Some whites argued that the approximately 187,000 to 200,000 blacks who joined the Union army would lack the courage and intelligence needed for combat. The story of USCT valor during the Siege of Petersburg and numerous other engagements proved otherwise. During the siege, USCTs showed tremendous valor, most notably during the Battle of the Crater. For this battle, the Union army developed an unorthodox plan to break Confederate lines by tunneling into the ground beneath enemy forces and igniting 8,000 pounds of explosives for a surprise attack. Approximately 4,000 black soldiers fought and 1,327 were casualties during this July 30, 1864, attack. For his heroism in the battle, a young USCT named Decatur Dorsey earned the Congressional Medal of Honor.

The following compilation of images first provides a glimpse of soldiers who fought in the city's noted Civil War battle. The chapter also shows Black life at Fort Lee, a military encampment adjacent to Petersburg. The images depict segregated life at Camp Lee and display the friendly refuge and support Petersburg's African American community offered black soldiers who arrived there from all over the nation.

CIVIL WAR RECRUITMENT POSTER FOR BLACK SOLDIERS. In battle after battle, USCTs proved themselves to be some of the Union army's most valiant soldiers. They served despite facing the highest risks. It was common practice for the Confederate army to disregard the rules of war and execute USCT prisoners of war or return them to slavery. This recruitment poster advertises the passage of a U.S. general order condemning the Confederate army's practice and promising retaliation. (Courtesy of the National Archives.)

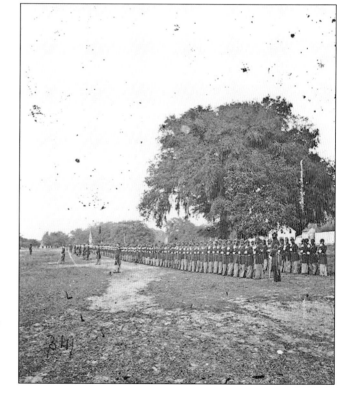

THE 29TH CONNECTICUT U.S. COLORED INFANTRY. Although the Union army permitted black volunteers, regiments were strictly segregated. The 29th Connecticut Regiment was one of 22 black regiments to participate in the Siege of Petersburg. More black soldiers participated in the siege than in any other Civil War engagement. (Courtesy of the Library of Congress.)

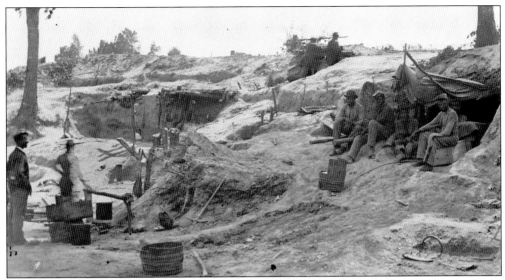

BLACK SOLDIERS IN THE SIEGE AND THE BATTLE OF THE CRATER. Pictured here are black soldiers behind the safety of large dirt pilings. Facing a formidable enemy, the Union army developed an unorthodox plan to break Confederate defenses by tunneling beneath Confederate lines and dynamiting their forces from below. The surprise and chaos of the explosion would allow Union soldiers to successfully advance. The USCT 4th Division was selected to lead the July 30, 1864, assault and were specially trained for weeks. Gen. George Gordon Meade, fearing political fallout from Washington, replaced the USCTs in the final hour with the combat-fatigued 1st Division, which had not received special training for the battle. The result was confusion on the battlefield, high Union casualties, and a failed assault. (Courtesy of the Library of Congress.)

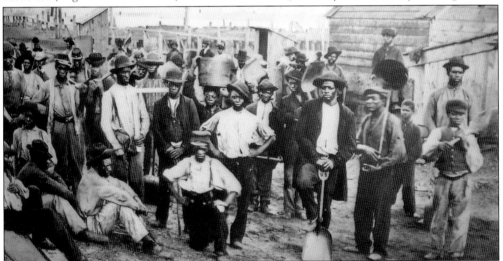

AFRICAN AMERICANS AT CITY POINT. City Point, located in Hopewell, Virginia, was the heart of the Union army's success during the Siege of Petersburg; Gen. U. S. Grant established his headquarters here. Its location on two important waterways, the Appomattox and James Rivers, was vital to the transport of supplies to Union troops on the front line of the siege. Each day, some 15,000 tons of supplies arrived by boat. Hundreds of formerly enslaved African Americans worked at City Point, unloading ships and supplying enormously valuable labor. (Courtesy of the Petersburg National Battlefield.)

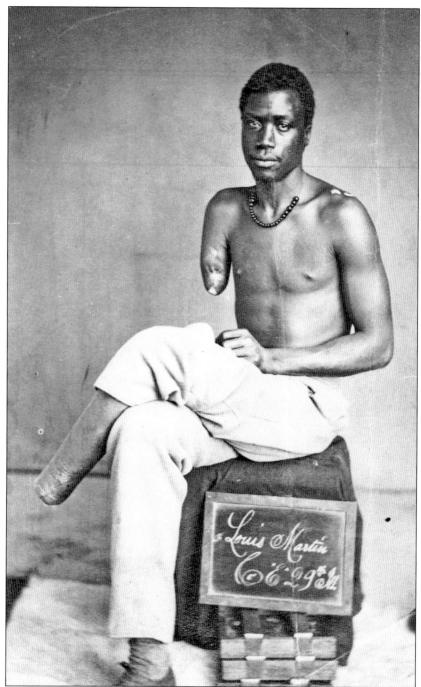

Pvt. Louis Martin, 29th U.S. Colored Infantry. Private Martin was born in Independence, Arkansas. In 1864, at the age of 25, he enlisted in the 29th Infantry of the USCT. As a member of this regiment, Martin participated in the Battle of the Crater. While charging the enemy, he was hit by shell fragments and a miniball, which destroyed his right arm and left leg. Both were amputated. Martin was hospitalized for over a year and a half for his injuries, but he survived and lived another 27 years. (Courtesy of the National Archives.)

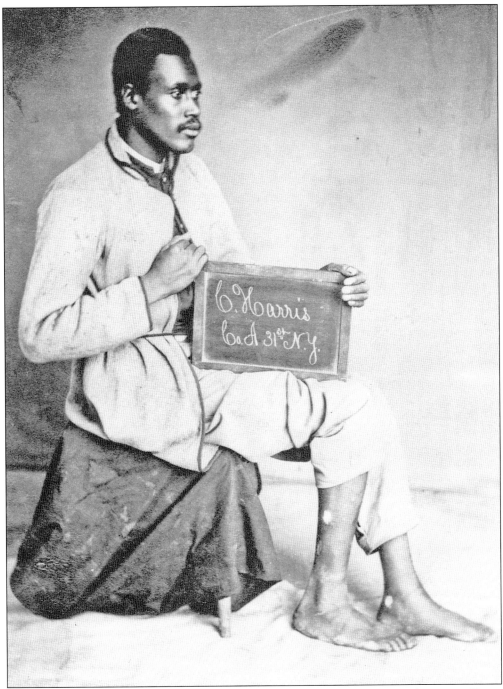

PVT. CHARLES HARRIS, 31ST INFANTRY USCT. Born in Lockhart, New York, Private Harris was a member of the 31st USCT at the age of 24. He fought and was wounded at the Battle of the Crater. (Courtesy of the National Archives.)

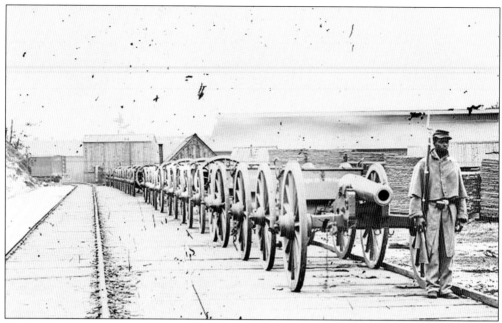

BLACK SOLDIERS AT CITY POINT. USCTs were the first to arrive at City Point, repair it, and establish it as a Union army outpost. (Courtesy of the Library of Congress.)

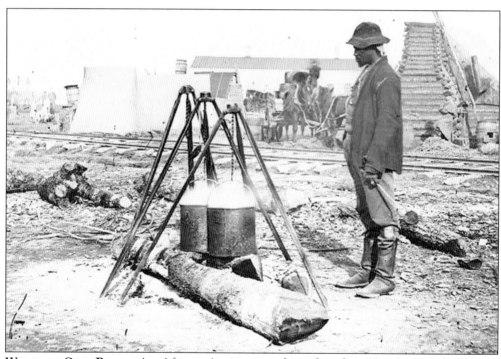

WORK AT CITY POINT. An African American cook tends a fire. (Courtesy of the Library of Congress.)

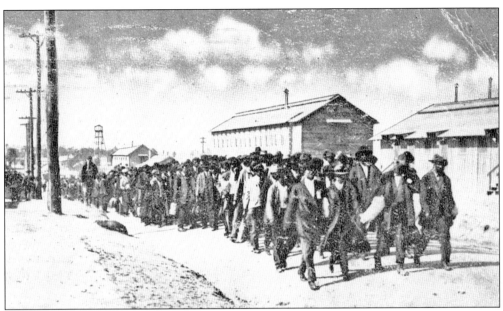

BLACK SOLDIERS ARRIVE AT CAMP LEE. Since its opening in 1917, black volunteers enlisting in the army arrived at Camp Lee from all over the South, including Virginia, West Virginia, Washington, D.C., and Maryland. Camp Lee closed after World War I but reopened in February 1941. In 1950, the camp officially became permanent as Fort Lee. (Courtesy of the Petersburg Museum Collection.)

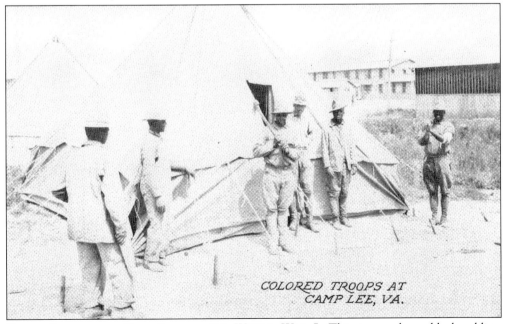

BLACK SOLDIERS AT FORT LEE DURING WORLD WAR I. This image shows black soldiers stationed at Camp Lee. These soldiers were likely members of the 80th Division. Although the 80th was originally stationed at Camp Lee, in 1918, they boarded the SS *Leviathan* and were shipped to France to join U.S. Army forces fighting in World War I. (Courtesy of the Quartermaster Museum.)

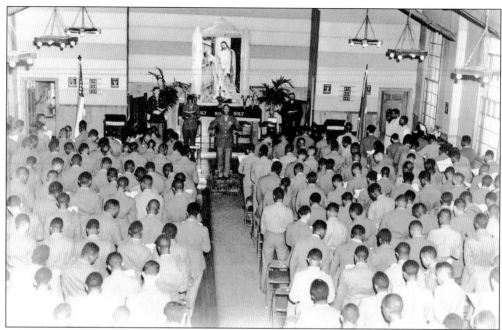

SEGREGATION OF SOLDIERS IN CAMP LEE. Until 1948, Camp Lee was racially segregated in most facets of everyday life. Although black and white soldiers normally trained together in areas such as the firing ranges and in the classroom, black soldiers lived in separate quarters, went to separate barbers, and joined separate YMCAs at the camp. Here in 1943, soldiers attend church service at one of Camp Lee's black chapels. With the execution of Executive Order 9981 in 1948, all U.S. Army facilities were integrated. (Courtesy of the Petersburg Museum Collection.)

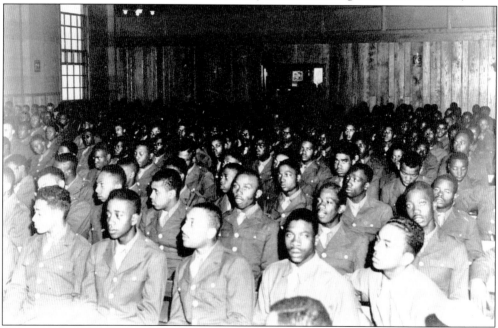

SOLDIERS IN A SEGREGATED CHURCH AUDIENCE, 1943. Typical of the Jim Crow era at Camp Lee, soldiers attend segregated church services. (Courtesy of the Petersburg Museum Collection.)

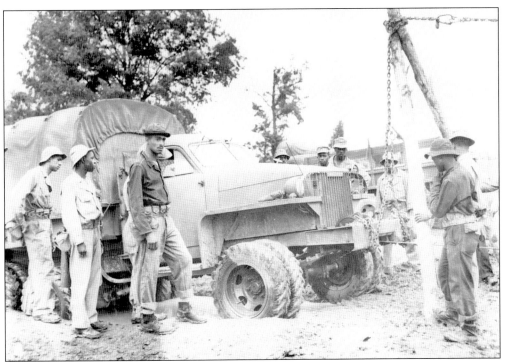

CAMP LEE RECOVERY CLUB. In this 1943 image, soldiers recover a truck in a training exercise. (Courtesy of the Quartermaster Museum)

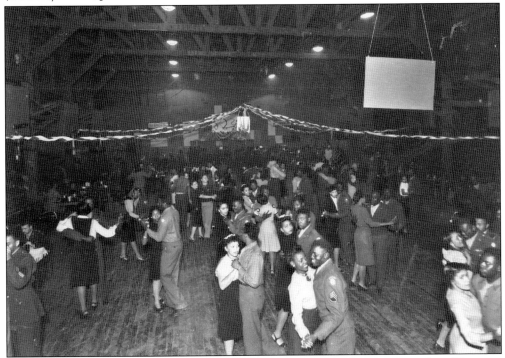

CAMP LEE DANCE. On November 15, 1946, 26th Company held a dance at Camp Lee. (Courtesy of the Petersburg Museum Collection.)

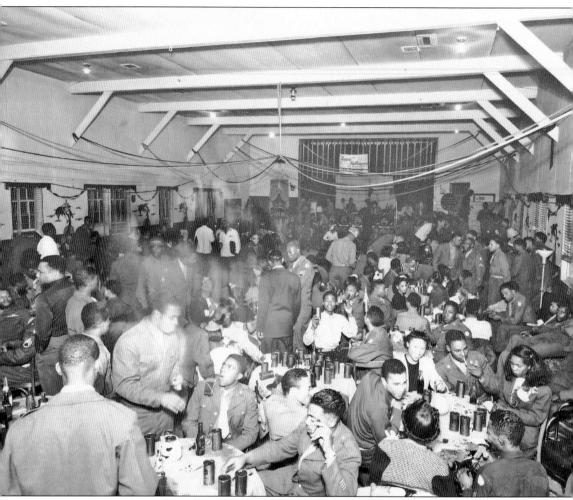

ENTERTAINMENT AT CAMP LEE. In this c. 1945 image, enlisted men of all ranks enjoy a party at Camp Lee. Depending on the function, wives and women from Petersburg and the surrounding area were allowed on base for festivities. (Courtesy of the Petersburg Museum Collection.)

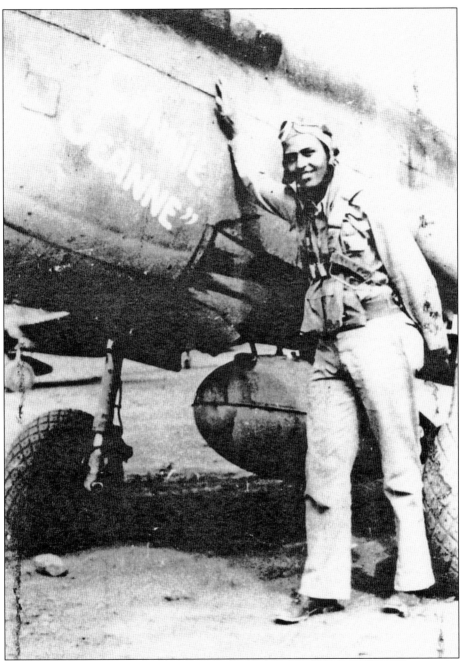

HOWARD L. BAUGH, TUSKEGEE AIRMAN. Baugh was born in Petersburg. Fascinated with flying since he was a young boy, Baugh joined the U.S. Army Air Corps after graduating from Virginia State College for Negroes. He joined a training program at Tuskegee Institute and was one of only four cadets to become pilots (12 cadets in his class attempted). Baugh flew World War II combat missions and was recognized along with his squadron for exemplary service. He served in the Air Corps for 25 years, until he retired in 1967. Baugh received several awards and commendations, including the French Legion of Honor. He is pictured with his aircraft. (Courtesy of Col. Porcher L. Taylor.)

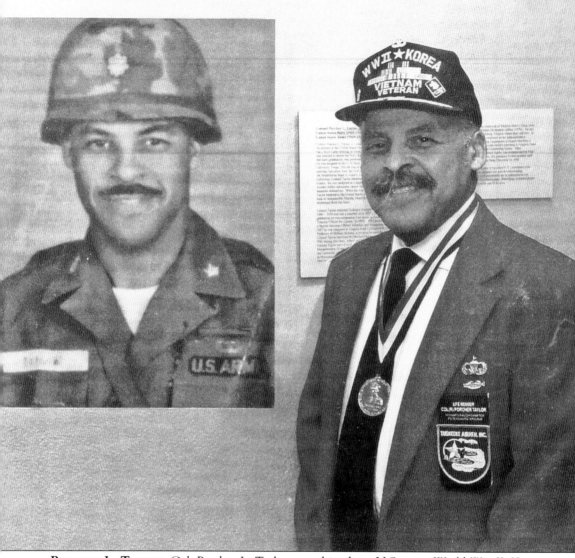

PORCHER L. TAYLOR. Col. Porcher L. Taylor served in three U.S. wars: World War II, Korea, and Vietnam. He served in both the navy and the army. Taylor earned his bachelor's degree from Tuskegee University, his master's degree from Virginia State College for Negroes and his Ph.D. from the University of South Carolina. For his service, he received the Legion of Merit, Bronze Star, Meritorious Service Medal, and Army Commendation Medal, and he is the recipient of the Distinguished Eagle Scout Award. As a longtime Petersburg resident, Taylor has collected and exhibited valuable military memorabilia, championed efforts to recognize Petersburg's military history, and promoted participation in the local Tuskegee Airmen Association chapter. (Courtesy of Col. Porcher L. Taylor.)

Three

A CITY OF CHURCHES

To discover the heart of the black community is to find its churches. These spaces of religious practice were centers of refuge during slavery and Jim Crow. They are places where social connections are formed and where acts of cultural and civic pride and community service are nourished and promoted. There may be no finer example of the longevity and importance of this tradition than in the African American churches of Petersburg, known to many as the "City of Churches."

Petersburg is home to First Baptist Church, believed to be the oldest African American Baptist church in the nation. Long before the Revolutionary War and the organization of the nation's states, in 1756, members of the New Lights began worship in Prince George County. By 1774, they had organized to found what is today First Baptist Church. Centuries later, this church community continues to be home to some of Petersburg's oldest families.

Despite the success of Petersburg's churches, their ability to survive and thrive over time has been tested. Following Nat Turner's slave rebellion in 1831, Virginia passed laws prohibiting the religious gathering of blacks, free or enslaved, without the presence of a white person. For many of Petersburg's black churches, this meant relinquishing their black religious leaders for white pastors. In the midst of these restrictions, black churches continued to meet and form. Following the Civil War, when this practice ended, African American churches returned to the leadership of black pastors.

During the civil rights movement, some of Petersburg's historic black churches and pastors were centers of activism and leadership. Meetings were held in churches like Zion Baptist Church and First Baptist Church; during the Sunday service, updates and information on protests and picketing was disseminated; and during the sermons, African Americans received direction, strength, and inspiration to continue the struggle.

Today churches have become focal points of community service. Their congregations provide essential programs such as child care, schooling, and youth programs.

The following photographs glance into the history of some of Petersburg's oldest churches. All have been in existence for over 100 years.

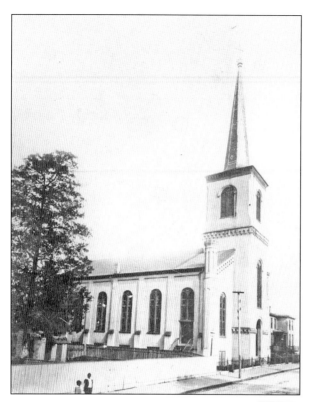

FIRST BAPTIST CHURCH. The oldest black Baptist church in the nation, First Baptist Church began as a small religious gathering in Prince George County called the New Lights. In 1774, they organized First African Baptist Church under Rev. John Michaels. The church occupied various locations until the completion of its present building in 1870. The building is pictured here around 1893. In 1890, Dr. E. M. Brawley began a school to teach adults to read and write. This school evolved into the first black public high school in Virginia, later known as Peabody High School. (Courtesy of First Baptist Church.)

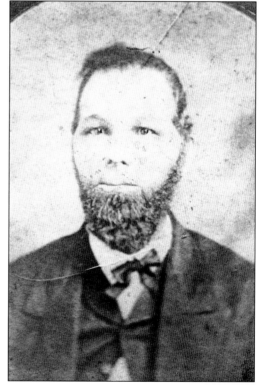

REV. LEONARD A. BLACK. Born enslaved in Maryland, Reverend Black served as pastor of First Baptist Church from 1873 to his death in 1883. He vastly increased church membership from 1,900 members to 3,600. He was held in great esteem in the community. On the day of his funeral, every store that employed a black person closed. (Courtesy of First Baptist Church.)

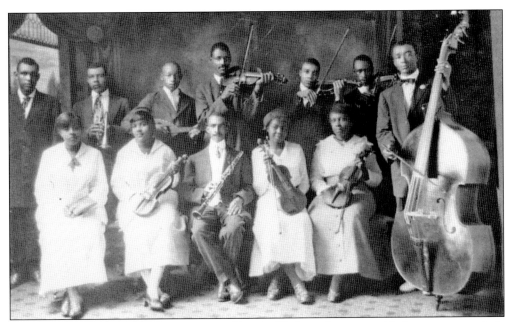

FIRST BAPTIST CHURCH ORCHESTRA. Church life has always provided numerous artistic outlets. Here is the church orchestra in the early 1900s. (Courtesy of First Baptist Church.)

GILLFIELD BAPTIST CHURCH. Gillfield Baptist Church is the second oldest black Baptist church in Petersburg. The church has its roots in a congregation of blacks and whites in Prince George County. By 1797, the group officially formed the Davenport Church and was located on land now occupied by Fort Lee. Around 1800, the congregation disbanded along racial lines, and its free black members settled on Pocahontas Island, where they renamed Davenport Church the Sandy Beach Church. In 1818, the congregation purchased Gill's Field. The present church building was completed in 1879. (Courtesy of Gillfield Baptist Church.)

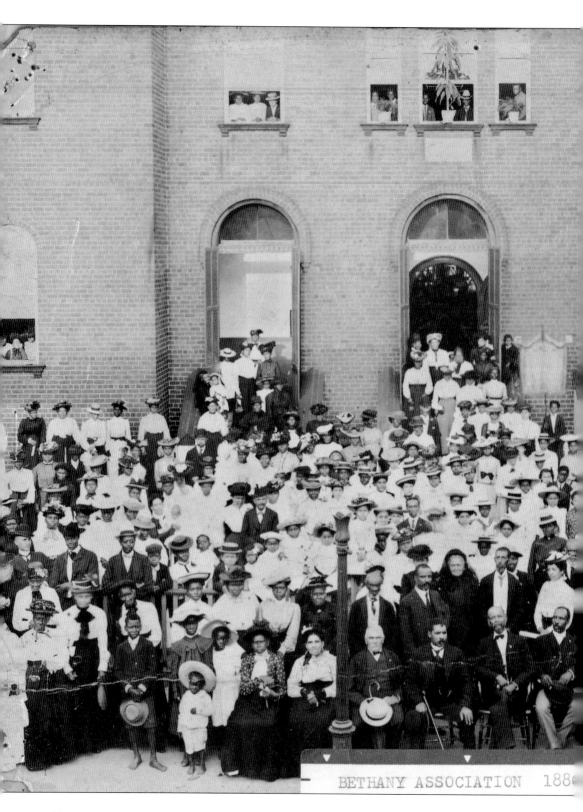

BETHANY ASSOCIATION 1886

BETHANY BAPTIST ASSOCIATION. In 1880, members of the Bethany Baptist Association assembled for a photograph in front of Gillfield Baptist Church, the association's host that year. (Courtesy of Gillfield Baptist Church.)

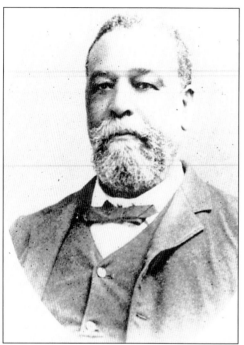

REV. HENRY WILLIAMS. An Ohio native, Reverend Williams was both an activist and a pastor. During slavery, Williams actively participated in the Underground Railroad. As a pastor, he showed exceptional leadership ability, growing the congregation of Gillfield Baptist Church to 2,500 during his 34 years as pastor (1865–1900) and training numerous pastors to serve in other churches. He was founder of the Bethany Convention, an association of churches. (Courtesy of Gillfield Baptist Church.)

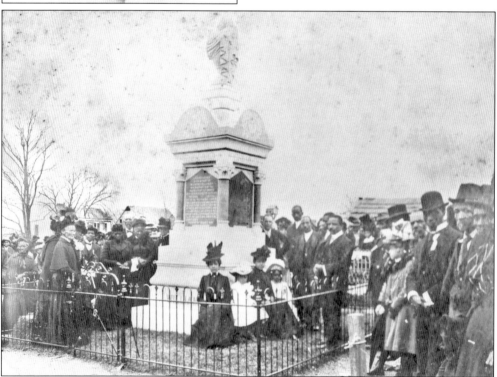

DEDICATION OF REV. HENRY WILLIAMS'S MONUMENT. This monument was erected in 1900 to honor Gillfield Baptist Church's longtime pastor, Rev. Henry Williams. The monument is located in eastern Blandford cemetery, stands 15 feet, 7 inches tall, and cost $1,480. Here church members participate in the monument's dedication. (Courtesy of Juanita Owens Wyatt.)

THIRD BAPTIST CHURCH. In 1842, members left Gillfield Baptist Church to organize the Third Colored Church, known today as Third Baptist Church, the third oldest black Baptist church in Petersburg. The Third Colored Church gathered at the Old Market Street Church and later purchased an abandoned schoolhouse at Lavender Lane and Rock Street (shown here). Early on, black pastor John Jasper led the congregation (a rarity for that time) with a white pastor, Reverend Keene, attending. (Courtesy of Third Baptist Church.)

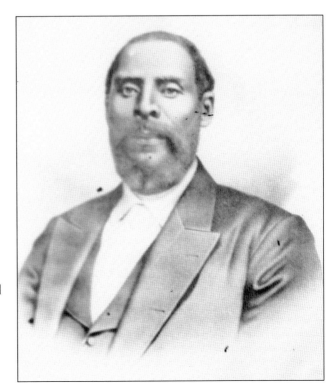

REV. JOHN JASPER. Jasper was born in 1812 and was the 24th child of Phillip and Tina Jasper in Fluvanna County. At the age of 27, Jasper became known for his lively sermons. As pastor of Third Baptist Church, Reverend Jasper was very successful. He grew the congregation and raised funds to pay off its debts. In 1866, Reverend Jasper resigned and went on to found other churches in the South that are still in existence. (Courtesy of Third Baptist Church.)

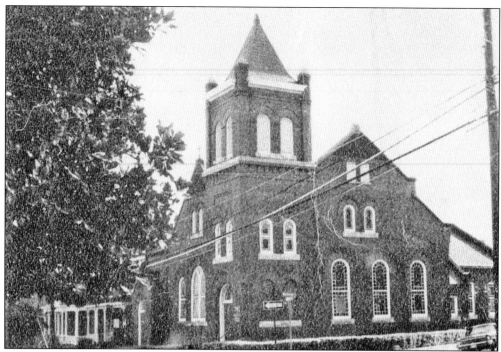

THIRD BAPTIST CHURCH, 1961. Third Baptist Church's congregation left their location at Lavender Lane and Rock Street and moved into the newly purchased former Wesley Methodist Church building located at 630 Halifax Street. (Courtesy of the City of Petersburg.)

THIRD BAPTIST CHURCH MAIN AUDITORIUM AT 630 HALIFAX STREET. Pictured is the interior of the Third Baptist Church building located on Halifax Street. (Courtesy of Third Baptist Church.)

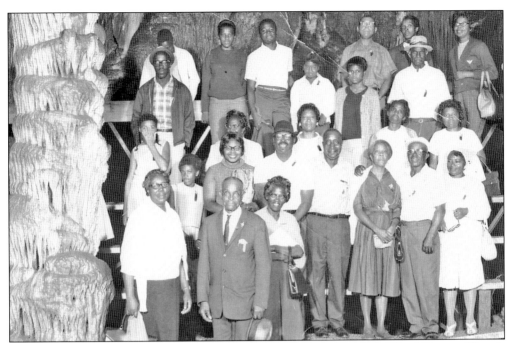

THIRD BAPTIST CHURCH GROUP AT LORAY CAVERNS. Pictured are Third Baptist Church members during a retreat to Luray Caverns in Virginia. (Courtesy of Third Baptist Church.)

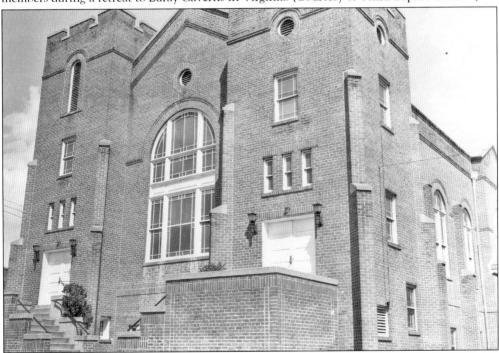

ZION BAPTIST CHURCH. Zion Baptist was organized in 1891, when 81 members of Third Baptist Church departed to form a new congregation. Zion Baptist Church services were originally held in the Coleman Masonic Lodge, but a permanent sanctuary was soon acquired at 225 Byrne Street. (Courtesy of Zion Baptist Church.)

ZION BAPTIST CHURCH'S FIRST BYRNE STREET SANCTUARY. The original Zion Baptist Church was constructed of wood. This structure was used until 1921, when it was replaced by the present-day sanctuary constructed of brick. (Courtesy of Zion Baptist Church.)

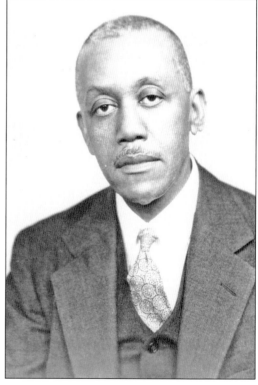

REV. JOHN BAPTIST BROWN. Reverend Brown came to Zion Baptist Church in 1902 and served until his death in 1939. His 37-year tenure was known to many as the "Golden Age" of Zion, as it signified large growth in church membership, activities, and community outreach. (Courtesy of Zion Baptist Church.)

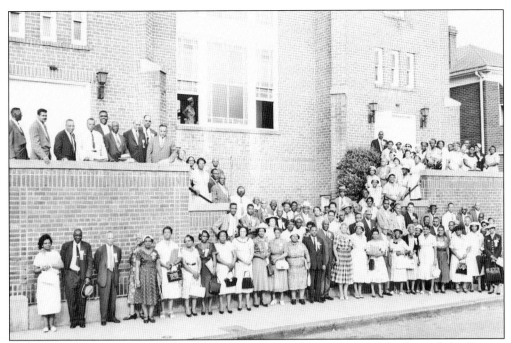

ZION BAPTIST CHURCH HOSTS BAPTIST GENERAL CONVENTION. Members of the Baptist General Convention pose in front of Zion Baptist Church, the host of the convention that year. (Courtesy of Zion Baptist Church.)

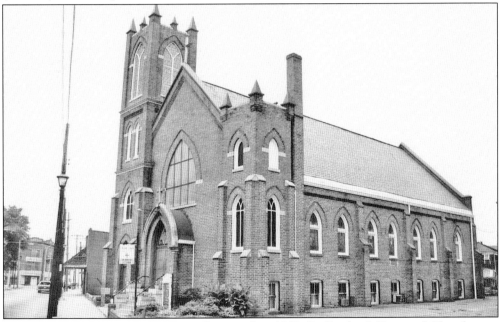

ST. STEPHEN'S EPISCOPAL CHURCH. Organized in 1868, St. Stephen's Episcopal Church grew out of the white and black congregation of Grace Episcopal Church. Black members, under the leadership of Caroline W. Bragg, left Grace Episcopal and organized St. Stephen's Episcopal Church on Perry Street. The church later moved to 228 Halifax Street. (Courtesy of St. Stephen's Episcopal Church.)

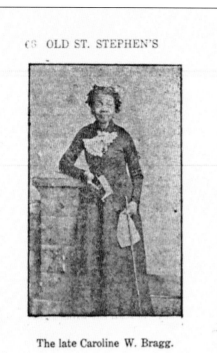

The late Caroline W. Bragg.

CAROLINE W. BRAGG. Bragg was known as the "Mother of St. Stephen's Episcopal Church." She contributed the first $5 toward the acquisition of the church's first building. Bragg was the mother of four sons, David Cain, John Cain, George Bragg, and Peter Bragg. Her sons all made significant contributions to the church and the Petersburg community. (Courtesy of *The Story of Old St. Stephen's Petersburg, Virginia*.)

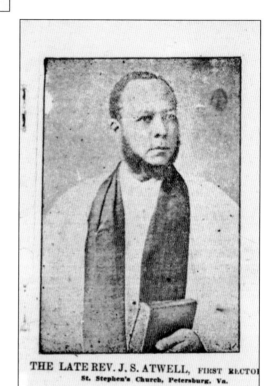

REV. J. S. ATWELL. Reverend Atwell served as the first rector of St. Stephen's Episcopal Church. (Courtesy of *The Story of Old St. Stephen's Petersburg, Virginia*.)

Mount Olivet Baptist Church on Gill Street. Founded between 1889 and 1891, Mount Olivet was originally located at 269 High Street, was named High Street Baptist Church, and was led by Rev. A. B. Callis, who was followed by Rev. Thomas M. Bowman. By 1901, under Reverend Bowman's leadership, a new wooden church building was constructed on Gill Street by architect and carpenter William A. Penn. Through years of hard work under the leadership of longtime pastor Dr. L. C. Johnson, in 1944, the church was renovated from a wooden structure to a brick building with lighting and central heating. The church community remained in this location for 54 years. (Courtesy of Mount Olivet Baptist Church.)

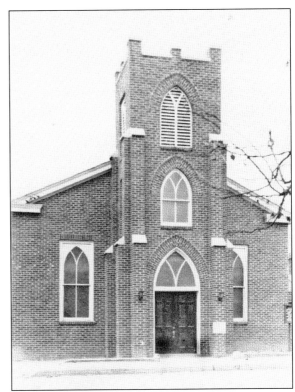

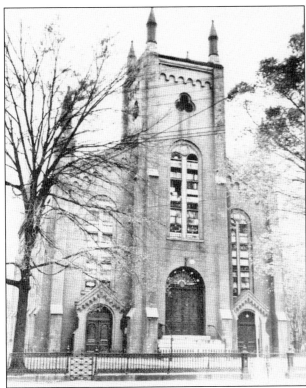

Mount Olivet Baptist Church on Market Street. On November 21, 1954, the Mount Olivet Baptist Church moved from its Gill Street location to a church building on Market Street, where the congregation remained until 1998 when it moved to its present-day location at 800 Augusta Avenue. (Courtesy of Mount Olivet Baptist Church.)

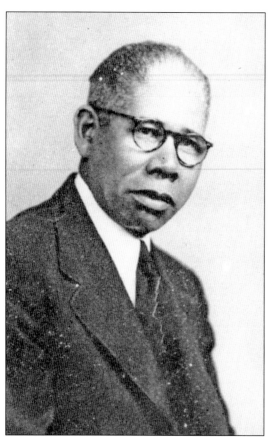

REV. DR. L. C. JOHNSON. Reverend Johnson came to serve as pastor of Mount Olivet Baptist Church in February 1936. During his 37 years of service, Reverend Johnson oversaw the growth of the congregation from 36 members to over 800 members, with assets growing from $200 to $244,000. When Reverend Johnson retired as pastor, the church was debt free and had a thriving church membership, a legacy that lives on today. (Courtesy of Mount Olivet Baptist Church.)

MOUNT OLIVET BAPTIST CHURCH LEADERS AND OFFICIALS IN 1951. From left to right are (first row) Sallie Hines, Lillie Bullock, Dorothy Hawkins, Rev. and Mrs. L. C. Johnson, Mary Crews, and Hattie Tucker; (second row) Charles Sherrod, Pearl Jackson, Docie Harris, Sarah Woodley, and John Hinnant; (third row) deacons Nathaniel Bullock, Percy Cox, Thomas Franklin, Henry Redd, Eddie Dyson, Walter Moore, and Peter Jones. (Courtesy of Mount Olivet Baptist Church.)

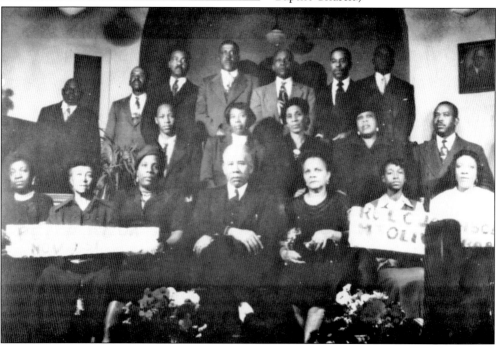

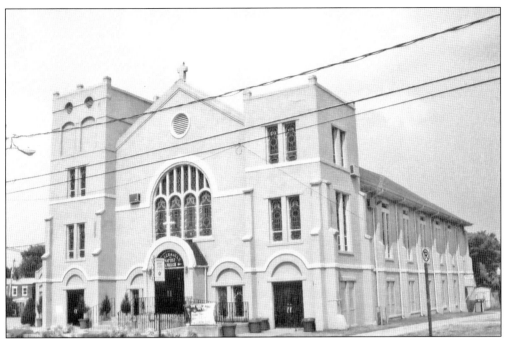

TABERNACLE BAPTIST CHURCH. The church held its first service on March 30, 1890, under the leadership of Rev. C. B. W. Gordon Sr. It started in a hall on Oak Street belonging to Anna Williams. Later the congregation purchased the present location (photographed here in 2008) at 418 Halifax Street for $2,000 and held worship service at this location on May 25, 1890. In the 1930s, Rev. Temple Ritchie served as supply pastor due to the declining health of Pastor Gordon. After Gordon's death, Rev. Fred Jacob Boddie Sr. was elected pastor on October 13, 1941. (Courtesy of Amina Luqman-Dawson.)

REV. C. B. W. GORDON. In 1890, Reverend Gordon left First Baptist Church to found Tabernacle Baptist Church. He served as pastor from 1890 until his health declined in the 1930s, when an interim pastor was employed. Pastor Gordon officially ended his position as pastor in 1941 at the time of his death. (Courtesy of First Baptist Church.)

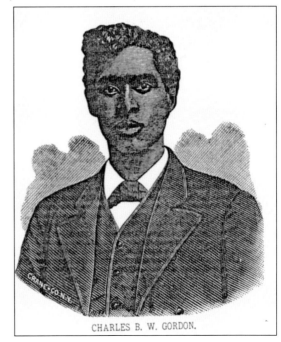

CHARLES B. W. GORDON.

OAK STREET AFRICAN METHODIST EPISCOPAL ZION CHURCH. Oak Street A.M.E. Zion began in 1818 as a mission church of the Washington Street Methodist Church. The congregation had both whites and blacks and was led by a white pastor. In 1879, the black members left to join with the A.M.E. Zion Church. That year, their present building was constructed. Oak Street is the oldest black Methodist church in Virginia. (Courtesy of the City of Petersburg.)

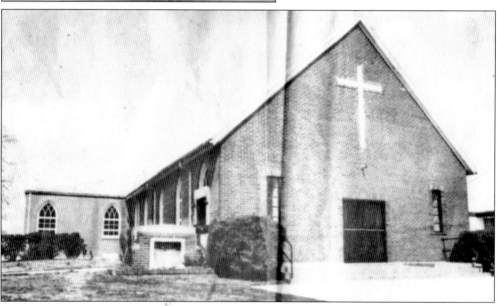

BETHANY BAPTIST CHURCH. Bethany traces its beginnings to 1891 with 10 men who met weekly at the home of Peter Greene. The group grew and began meeting at Blandford Chapel. In 1893, the congregation moved into a small tavern at Crater Road and Miller Street. There the group became organized with its first pastor, Rev. Peter R. Berry. In 1901, Bethany Baptist Church moved its location to Wythe Street, first into a wood-frame building, then into the present brick building completed in 1925. (Courtesy of Bethany Baptist Church.)

Four

THE STRUGGLE FOR EQUALITY

When civil rights activist Wyatt Tee Walker first arrived in Petersburg in 1952 to serve as pastor of Gillfield Baptist Church, he described it as "the most segregated town in Virginia." Poll taxes, unfair testing, and intimidation were used to keep blacks from registering to vote. Blacks and whites in Petersburg were living separate and unequal lives.

By February 23, 1960, black students, primarily from Peabody High School, were at the forefront of the fight for civil rights. In Petersburg, blacks could purchase from lunch counters, but they were not permitted to sit and receive service. Fifteen to 20 black students took seats and asked for service at S. S. Kresge Company, a popular Petersburg store. On the same day, smaller groups of students did the same at McLellan's and at the W. T. Grant Company. No one was arrested; all three stores temporarily closed their lunch counters.

The flashpoint for organized protest in Petersburg was the desegregation of the city's public library. At the center of these efforts was Rev. Wyatt Tee Walker. He saw no more appropriate place to begin the fight for desegregation than the public library. The segregated library restricted black patrons to the use of the library's side entrance and a poorly lit basement. The remaining floors and library stacks were reserved for whites. On February 27, 1960, some 140 African Americans, primarily students from Peabody High School and Virginia State College, entered the library through the main entrance and took all of its available seats. As a result, the library was closed for four days to all patrons, and the city council, despite pleas to end library segregation, passed a strict anti-trespassing ordinance to discourage protests. Undeterred, on March 7, 1960, fifteen black patrons entered the library's front door and took seats. Eleven were arrested for violating the ordinance, five of whom stayed in jail for over 40 hours.

Following the library sit-in, organized protest flourished, with demonstrations at the Blue Bird Theater, Spiro's department store, the Century Theater, the Trailways bus station, and other locations. The efforts of Peabody High School students, Virginia State College students, and ordinary citizens resulted in the desegregation of lunch counters and other private businesses, government facilities, stores, and other facets of Petersburg life. They registered voters, changed racially biased hiring practices, and laid the foundation for representation of blacks in city jobs, city council, and administration positions.

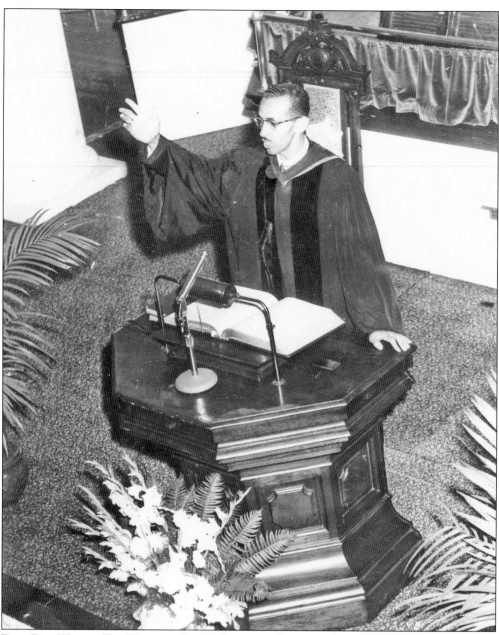

REV. DR. WYATT TEE WALKER. Dr. Walker arrived in Petersburg in 1952 to serve as pastor of Gillfield Baptist Church and quickly became a leader in Petersburg's civil rights movement. Walker was a principal organizer of the Petersburg Public Library protests. He was president of the local branch of the NAACP, statewide director of the Congress for Racial Equality (CORE), and founder of the Petersburg Improvement Association (PIA). Based on the Montgomery Improvement Association, the PIA was a federation of local organizations, including the NAACP and later the Southern Christian Leadership Conference. Following the library sit-ins, the PIA was the primary mechanism for organized protest in Petersburg. In 1960, Dr. Walker left Petersburg to become a national civil rights figure as the chief of staff for Dr. Martin Luther King Jr. and became nationally recognized for his work. (Courtesy of Rev. Dr. Wyatt Tee Walker.)

Rev. Robert G. Williams. Reverend Williams was pastor of Zion Baptist Church and a civil rights leader. Once Reverend Walker left Petersburg, Williams became the president of the PIA, a major element in the organization of protests in Petersburg. In the early 1960s, Williams participated in and organized numerous demonstrations, including participating in the library sit-in of March 1960 and successfully organizing protests to desegregate the Trailways bus station. (Courtesy of Zion Baptist Church.)

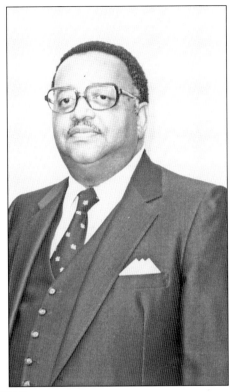

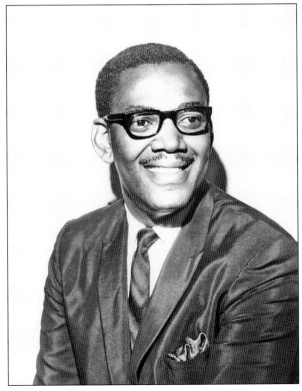

Dr. Milton A. Reid. Dr. Reid, a native of Chesapeake, Virginia, came to Petersburg to serve as pastor of First Baptist Church in 1957. Dr. Reid was a major actor in the Petersburg civil rights movement. He founded the statewide branch of the Southern Christian Leadership Conference (SCLC) and started SCLC branches in approximately 22 counties and cities throughout Virginia. (Courtesy of Dr. Milton A. Reid.)

HERBERT COULTON. A native of Petersburg, Coulton played an important organizing role in the civil right movement in Petersburg and throughout Virginia. In 1961, he worked as the Virginia field director of the SCLC, registering black voters throughout Virginia. This was a daunting task, resulting in Coulton's arrest and harassment on more than one occasion. He was later hired by Dr. Martin Luther King Jr. to serve as the SCLC's director of affiliates. Coulton has had a long career of civil rights activism, and today, he works to keep Petersburg's civil rights legacy alive. (Courtesy of Herbert Coulton.)

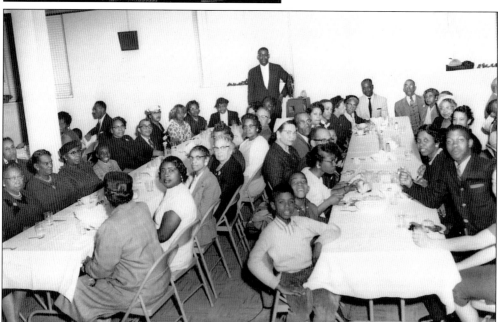

ACTIVISM IN THE BLACK CHURCH. With active pastors at the helm, churches such as First Baptist and Zion Baptist became central locations for civil rights organization and activism. They provided meeting spaces, a network through which news of movement activities could be disseminated, and spaces to receive inspiration and guidance from the pulpit. Pictured here, a meeting is taking place at First Baptist Church on Harrison Street led by Dr. Milton A. Reid. (Courtesy of Dr. Milton A. Reid.)

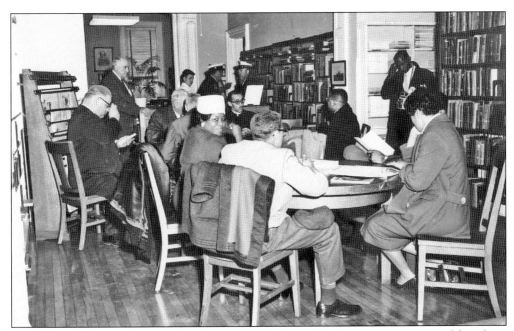

DESEGREGATING THE LIBRARY. On March 7, 1960, eleven black patrons were arrested for taking seats in the library's whites-only section. They were pastors Wyatt Tee Walker and Robert G. Williams; Virginia State College students Lillian Pride, Sandra Walker, Edwin W. Jordan, Robert Williams, Foster B. Miles, and Virginius Thornton; Peabody High School students Horace Brooks and Leonard Walker; and business owner Cassie Walker. Here, they are sitting in protest as warrants are signed for their arrest. (Courtesy of the *Richmond Times Dispatch*.)

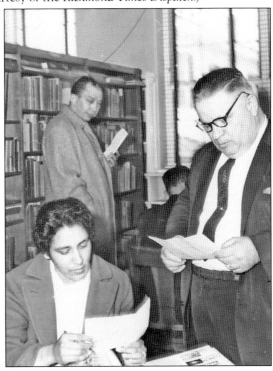

VIRGINIA STATE COLLEGE STUDENT ARRESTED. Six of the March 7 library protesters arrested were students from Virginia State College. Student Lillian Pride is being served an arrest warrant by police chief W. E. Traylor for sitting in the whites-only section. Each week, Pride worked at Gillfield Baptist Church typing the church bulletin. There she learned of the plans for the library sit-in from Reverend Walker. She agreed to participate and invited her college classmates Sandra Walker and Foster Miles to join her. (Courtesy of the *Richmond Times Dispatch*.)

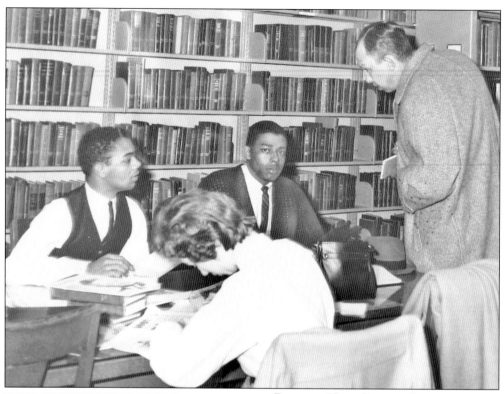

PEABODY HIGH SCHOOL STUDENTS ARRESTED. Here on March 7, 1960, Peabody High School seniors Leonard Walker (left) and Horace Brooks (right) are seated in protest in the Petersburg Public Library. They are being informed that they are trespassing by Sgt. A. V. Bowen. Both students were arrested, along with nine others. Youth participation in the civil rights movement was an essential element of Petersburg protests. (Courtesy of the *Richmond Times Dispatch*.)

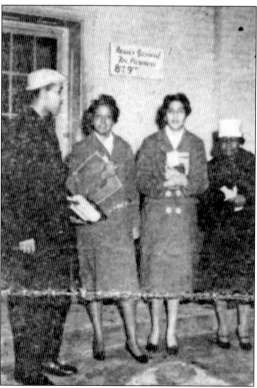

LIBRARY PROTESTERS RELEASED FROM JAIL. On March 7, 1960, six of the eleven library protesters were released on bond the evening of their arrest for their protest of segregation in the public library. These four newly released protesters, from left to right, are Edwin Jordan, Sandra Walker, Lillian Pride, and Cassie Walker immediately after being released on bond. (Courtesy of the *Richmond Times Dispatch*.)

PRAYERFUL PROTEST. The 11 arrested in the library protest were charged under an anti-trespassing ordinance and faced a fine of up to $1,000 and up to a year in jail. Six of the arrested protesters immediately posted bond and were quickly released. The remaining five refused bail and stayed in jail for two nights in protest. In a show of solidarity on the evening of March 8, 1960, some 200 people staged a prayer protest on the steps of the courthouse. (Courtesy of the *Richmond Times Dispatch*.)

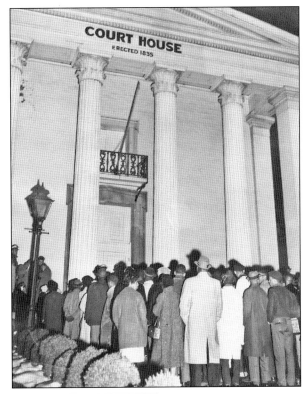

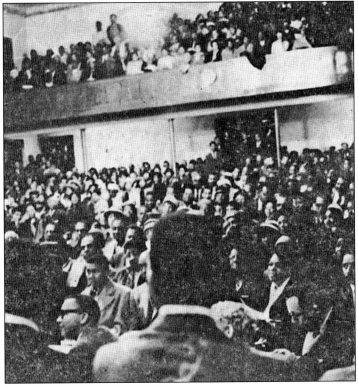

ZION BAPTIST CHURCH MEETING. Braving the snow on the evening of March 9, 1960, over 1,400 people gathered at Zion Baptist Church. Among others, the crowd was addressed by those released from jail after protesting the segregated library. A telegram was read from Dr. Martin Luther King Jr., $1,115 was collected in donations for the library protesters, and plans were made for future protests. Although no announcement was made until the meeting's end, the church received six bomb threats during the meeting. (Courtesy of the *Progress Index*.)

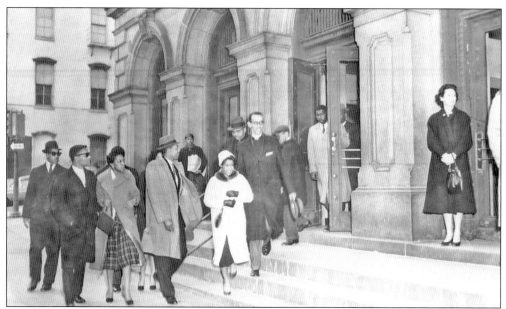

LIBRARY PROTESTERS FILE AN INJUNCTION. On March 14, 1960, the 11 library protesters were all convicted under the city's anti-trespassing ordinance. The next day they filed an injunction in Federal District Court in Richmond seeking for the court to end the "humiliating" and "unconstitutional" practice of segregation in the library. More than 180 people in 30 cars caravanned from Petersburg to Richmond for the court filing. Starting fourth from the left to right, Horace Brooks, Ann Walker, and Rev. Wyatt Tee Walker descend the courthouse steps. (Courtesy of Dr. Margaret Crowder Johnson.)

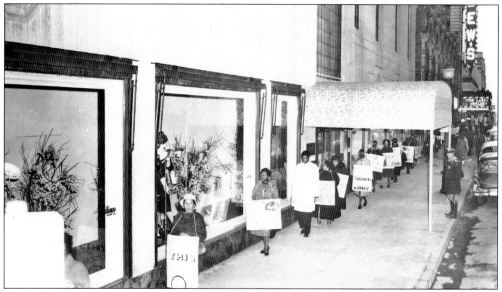

PETERSBURG PROTESTERS JOIN PICKET LINE IN RICHMOND. Desegregation and civil rights protests took place all over the South. It was not unusual for African American communities from different towns to pool their resources and support one another in protests. Here Ruth Washington of Petersburg joins in a protest to desegregate Richmond's Thalhimer's department store. (Courtesy of Dr. Margaret Crowder Johnson.)

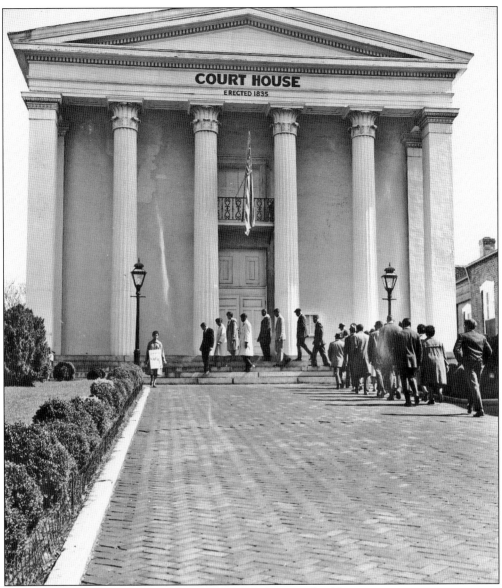

STUDENTS MARCH THROUGH PETERSBURG. Following the library sit-in, numerous protests were organized to desegregate various facets of Petersburg life. On March 1, 1961, a total of 600 Peabody High School and Virginia State College students marched silently through downtown Petersburg in groups of 30. The march protested Petersburg's segregated schools and theaters and was in solidarity with other black demonstrators who had been arrested during protests in the South. The demonstration was sponsored by the NAACP youth chapter. (Courtesy of the *Richmond Times Dispatch*.)

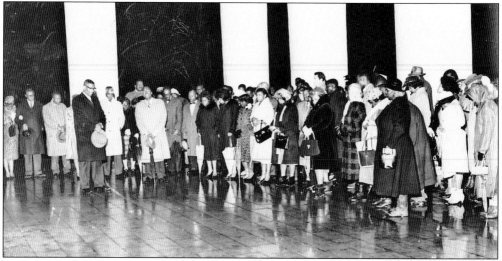

PILGRIMAGE OF PRAYER FOR PUBLIC SCHOOLS. African American communities in Virginia joined to protest the closing of schools in Prince Edward County. The closing, also known as massive resistance, was employed by white residents of Prince Edward County to thwart the U.S. Supreme Court's *Brown v. Board of Education* decision and prevent integration. On January 1, 1959, Dr. Milton A. Reid addresses protesters in a pilgrimage of prayer at the Virginia State Capitol Building for the reopening and desegregation of Prince Edward schools. (Courtesy of Dr. Milton A. Reid.)

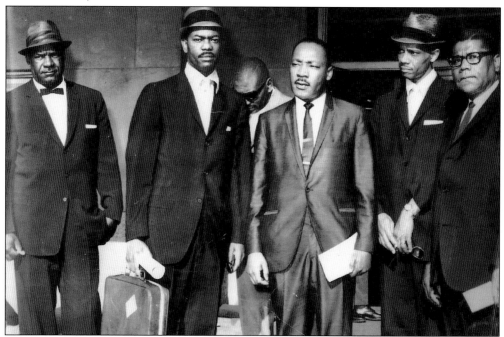

DR. MARTIN LUTHER KING JR. IN PETERSBURG. During the civil rights movement, Dr. Martin Luther King Jr. visited Petersburg on at least three occasions. Pictured here in 1962 (from second to the left to the right) are Herbert Coulton, chair of the Petersburg branch of the SCLC; Dr. Martin Luther King Jr.; Hermanze E. Fauntleroy; and David Gunter, president of the PIA. (Courtesy of Mr. Herbert Coulton.)

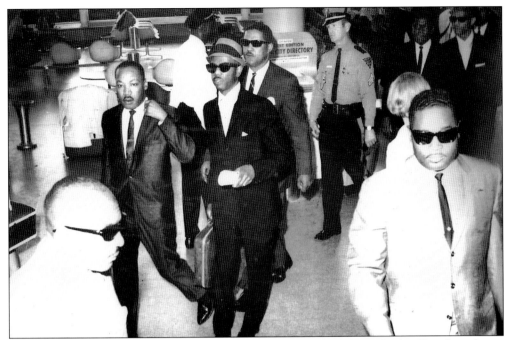

DR. MARTIN LUTHER KING JR. TRAVELS TO PETERSBURG. Dr. Martin Luther King Jr. is shown here on his way to speak in Petersburg in 1962. Herbert Coulton is at his side. (Courtesy of Mr. Herbert Coulton.)

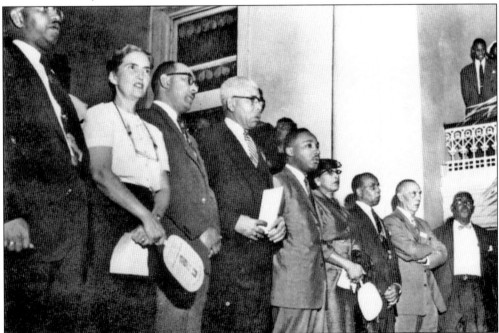

DR. MARTIN LUTHER KING JR. AT MOUNT OLIVET BAPTIST CHURCH. On October 5, 1956, Dr. Martin Luther King Jr. gave the keynote address at a mass meeting held in the auditorium of Mount Olivet Baptist Church. King's speech was entitled "Desegregation and the Future." (Courtesy of Mount Olivet Baptist Church.)

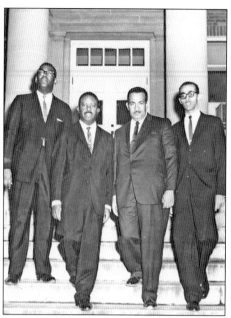

REV. RALPH ABERNATHY COMES TO PETERSBURG. Petersburg became known as a focal point of civil rights activism. As a result, many of the civil rights movement's most influential national figures visited Petersburg on numerous occasions. Pictured here in the early 1960s are, from left to right, Rev. Milton A. Reid, Rev. Ralph Abernathy, Rev. L. Francis Griffin from Farmville, and Rev. Wyatt Tee Walker. (Courtesy of Dr. Margaret Crowder Johnson.)

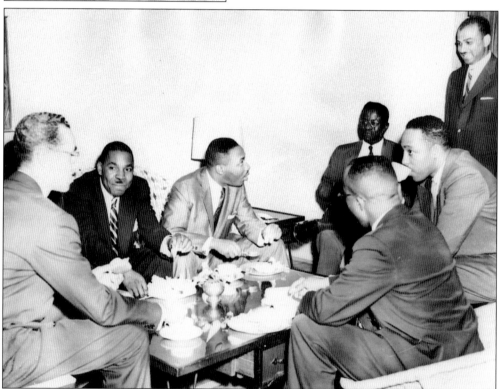

PASTORS MEET WITH DR. KING. Here pastors meet with Dr. Martin Luther King Jr. in Gillfield Baptist Church's parsonage at 312 South Dunlop Street. From left to right are Rev. Wyatt Tee Walker, Rev. Robert Taylor of Richmond, Dr. Martin Luther King Jr., Rev. Harry Roberts, Rev. William "Bill" Barnett, Rev. Leroy Green (standing), and unidentified (sitting). (Courtesy of Dr. Margaret Crowder Johnson.)

EDWIN JORDAN AND LEN HOLT. Pictured here are Virginia State College student Edwin Jordan (left) and Len Holt (center) of the Congress of Racial Equality (CORE). Holt traveled throughout the South, providing needed counsel to thousands of civil rights protesters and legal advice on civil rights strategies. The two are at a conference at Shaw University in Raleigh, North Carolina, as part of a delegation from Petersburg. The conference resulted in the founding of the Student Non-Violent Coordinating Committee (SNCC). (Courtesy of Sandra Walker Howell.)

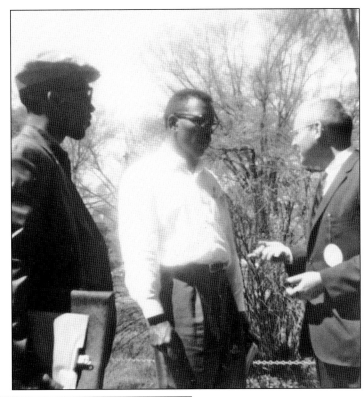

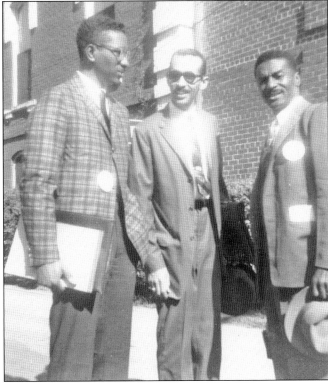

THE FOUNDING OF SNCC. Petersburg sent a large delegation to Shaw University for the founding meeting for the SNCC. Conference attendees from left to right are Virginius Thornton, Rev. Wyatt Tee Walker, and national activist Fred Shuttlesworth. Thornton was a graduate student at Virginia State College, a leader in the library sit-in, and a long time organizer. Thornton served as the co-vice president the PIA, a center of political action during the civil rights movement. (Courtesy of Sandra Walker Howell.)

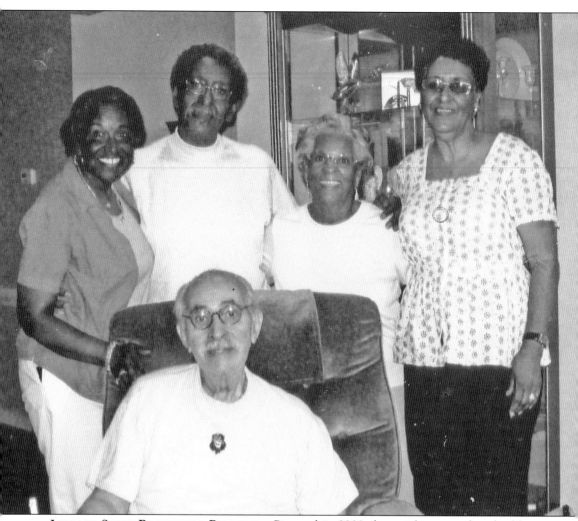

LIBRARY SIT-IN PROTESTERS REUNITED. Pictured in 2008, forty-eight years after the library sit-in, protesters met to reminisce. Pictured are Rev. Dr. Wyatt Tee Walker (front center); Sandra Walker Howell; Dr. Foster Miles; Theresa Ann Walker, Dr. Walker's wife; and Lillian Pride Smith. (Courtesy of Amina Luqman-Dawson.)

Five

A NEW DAY IN POLITICS

Upon emancipation, African Americans emerged from the confines of slavery eager to claim full rights as citizens and play a role in the political destinies of their communities. The passage of the Reconstruction Acts of Congress of 1867, granting black males the right to vote, ushered in a new and dynamic period of African American political representation throughout the South. No Virginia city was better positioned to reap the benefits of these newly earned rights than Petersburg.

By the 1960s, Petersburg's era of Reconstruction politics was a distant memory, and the South was entrenched in the legacy of Jim Crow. Yet there was also a promise of change in an African American community awash in the excitement of the civil rights movement. Although the movement's earliest efforts resulted in great gains in desegregation and equal rights, local civil rights activists quickly recognized that the door to full political representation remained closed to African Americans. Despite their substantial percentage in the city's population, African Americans held no positions on city council or among city administrators.

African American invisibility in the political arena had clear implications. African Americans, regardless of their class, had little say in the distribution of the city's resources. Moreover, the city's black poor were completely disenfranchised and economically depressed, living in some of the worst housing stock in the nation. Civil rights activists recognized these racial and economic disparities and began focusing their energies on gaining greater political representation.

Their efforts resulted in the 1964 election of Joseph Owens, the city's first African American councilmember since Reconstruction, and in the 1966 election of Hermanze Fauntleroy. Their elections to council were a significant feat. At the time council members were elected in an at large voting system that disenfranchised black voters and left them vulnerable to a white electorate unwilling to vote for black candidates. By the early 1970s, the city was in the process of annexation, which would further enlarge white voting power. In response to efforts of councilmember Fauntleroy and members of the Petersburg Voter Education Council (PVEC), a successful political and legal battle ensued that resulted in a fairer ward voting system. In 1973, the fruits of their labor culminated in the historic special election of Virginia's first majority black city council. Numerous black candidates from Petersburg were elected to local and state offices.

Petersburg Reconstruction Era
Members of the Virginia House of Delegates and Members of the City Council

Joseph P. Evans
House of Delegates 1871-73
Senate 1874-75

William E. Evans
House of Delegates 1887-1888
City Gauger

Alfred W. Harris
House of Delegates 1881-1888

George L. Fayerman
House of Delegates 1869-1871
City Council 1874-1876

James P. Goodwyn
House of Delegates 1874-75

Armistead Green
House of Delegates 1881-1884

William H. Jordan
House of Delegates 1885-1887
City Council

John W. B. Mattews
House of Delegates 1871-1873

Peter G. Morgan
House of Delegates 1869-1871
City Council
School Board

James E. Hill
City Council

John Henry Hill
City Council

James M. Smith
City Council

Henry Williams
City Council

PETERSBURG MEMBERS OF THE HOUSE OF DELEGATES AND CITY COUNCIL, 1865–1895. By the Civil War's end, Petersburg had the largest African American population in proportion to whites of any Virginia city. With this substantial black voting power, Petersburg gained the proud distinction of being the only city continuously represented in the Virginia legislature by a black office holder from 1865 to 1895. Listed here are Petersburg office holders during that dynamic era. (Courtesy of *Negro Office Holders in Virginia*.)

WILLIAM W. EVANS, HOUSE OF DELEGATES. William W. Evans served as a delegate from 1887 to 1888. He was born a slave in Dinwiddie County and relocated to Petersburg soon after the Civil War. In Petersburg, Evans worked as a barber, later purchased real estate in the city, and became a self-taught lawyer. His father, Joseph P. Evans, also served in the Virginia House of Delegates. (Courtesy of *Negro Office Holders in Virginia*.)

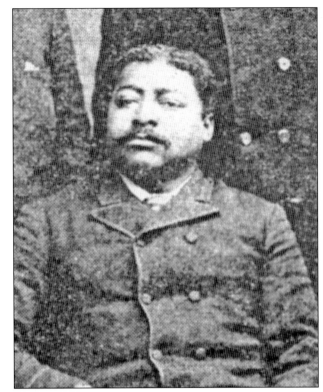

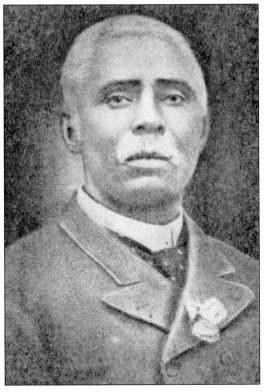

ALFRED W. HARRIS, HOUSE OF DELEGATES. Alfred Harris descended from a large family of free blacks in Fairfax and Prince William Counties. Soon after earning his law degree at Howard University, Harris moved to Petersburg and opened a practice located at 26 Sycamore Street. Harris was a delegate from 1881 to 1888. He was known as a skillful orator and debater in the general assembly. Harris authored a house bill to establish the Virginia Normal and Collegiate Institute, and using his powerful oratory skills, he successfully defended his bill before the legislature. (Courtesy of *Negro Office Holders in Virginia*.)

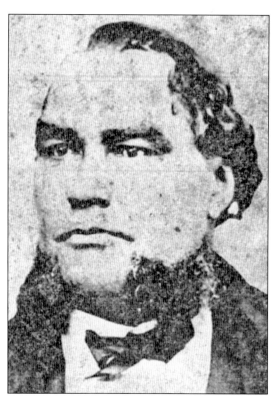

PETER MORGAN, HOUSE OF DELEGATES. Born enslaved in Nottoway County, Morgan used extra money he earned working as a shoemaker to purchase his freedom and that of his family. He arrived in Petersburg during the Civil War and became politically active at the war's end. He was elected to the city council and served on the school board. In 1869, Morgan was elected to the House of Delegates, where he served for two years. (Courtesy of *Negro Office Holders in Virginia*.)

JAMES E. HILL, CITY COUNCIL. Born in 1859, James E. Hill served on the city council and school board and was the clerk of the city market. He was employed as a tobacco factory worker. (Courtesy of *Negro Office Holders in Virginia*.)

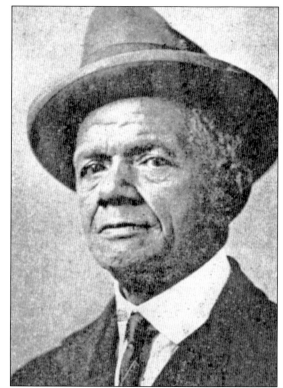

JOHN HENRY HILL, CITY COUNCIL. Born a slave in Petersburg, John Henry Hill escaped bondage and fled to Canada. Following the end of the Civil War, Hill returned to Petersburg and actively participated in local politics. He died in 1884. (Courtesy of *Negro Office Holders in Virginia*.)

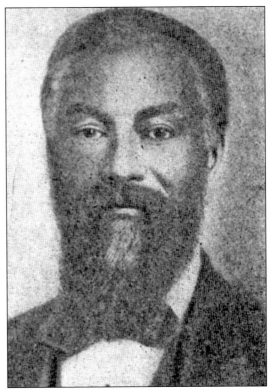

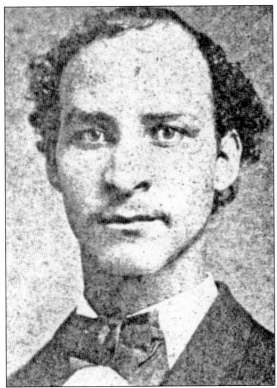

JAMES M. SMITH, CITY COUNCIL. Smith was a successful grocer who served on the city council. He died in 1928. (Courtesy of *Negro Office Holders in Virginia*.)

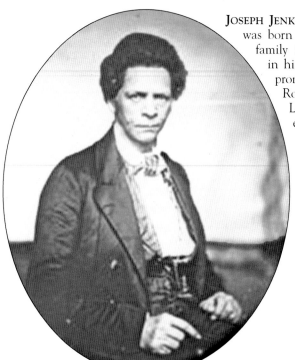

JOSEPH JENKINS ROBERTS. Joseph Jenkins Roberts was born free in Norfolk and settled with his family in Petersburg early in life. Following in his father's footsteps, Roberts became a prominent shipping merchant. In 1829, Roberts and his family left Petersburg for Liberia. At the time, the United States encouraged and at times forced the relocation of blacks to Liberia. Roberts worked to colonize Liberia and later served as its first president from 1848 to 1855 and a second time from 1871 to 1876. (Courtesy of the Library of Congress.)

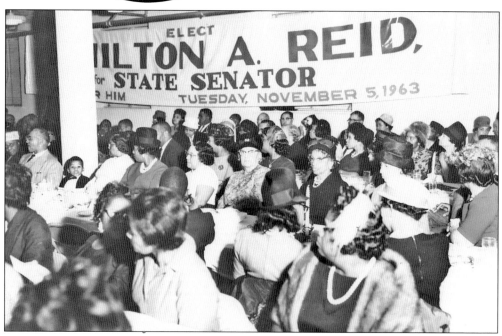

PASTOR MILTON A. REID RUNS FOR STATE SENATE, 1963. Seeking greater political representation for African Americans, in 1963, Pastor Reid of First Baptist Church ran for state senate. Although Reid didn't win the race, it helped mobilize community residents for other successful campaigns. Joseph Owens served as Reid's campaign manager. (Courtesy of Dr. Milton A. Reid.)

JOSEPH OWENS. In 1964, Joseph Owens became the first African American elected to the Petersburg city council since Reconstruction. Pastor Milton A. Reid served as Owens's campaign manager. Owens, an entrepreneur, owned a dry cleaning service at 250 Halifax Street. He served one term on the city council, until 1968. (Courtesy of Juanita Owens Wyatt.)

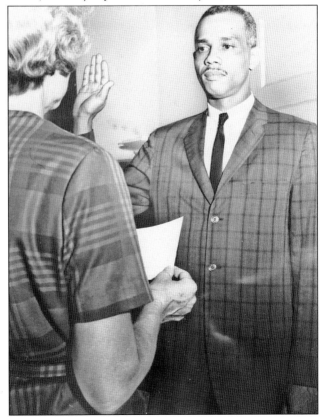

HERMANZE FAUNTLEROY. In 1966, Hermanze Fauntleroy became the second African American elected to the Petersburg City Council since Reconstruction. Fauntleroy, a teacher at Peabody High School, was forced by a discriminatory city administration to resign his 12-year teaching tenure in order to serve on the city council. He served on the city council for 20 years. By 1968, Fauntleroy was the sole African American member of council. Despite this, he successfully advocated for policies and measures to improve the condition of African Americans, including the establishment of the Petersburg Redevelopment and Housing Authority and converting the city from an at large voting system to a fairer ward system. (Courtesy of the *Richmond Times Dispatch*.)

BESSIE JONES. Bessie Jones, a Petersburg native, teacher, civil rights activist, and president of the Petersburg Voter Education Council (PVEC), made a significant contribution to increasing representation of African Americans on Petersburg City Council. In the 1970s, PVEC registered voters and mobilized efforts to change local election voting from an at-large system which disenfranchised African American voters to a ward system of government. This change ultimately led to the city's first majority African American city council. (Courtesy of Bessie Jones.)

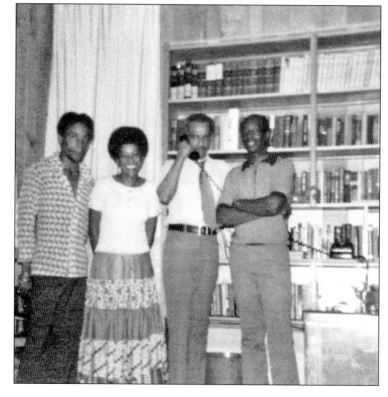

THE FIRST MAJORITY BLACK CITY COUNCIL. On June 12, 1973, under the newly implemented ward voting system, Petersburg elected its first majority black city council. Pictured here at their victory party are the winning candidates. From left to right are Roy Hines, Dr. Florence Farley, Hermanze Fauntleroy, and Rev. Clyde Johnson. (Courtesy of Dr. Florence Farley.)

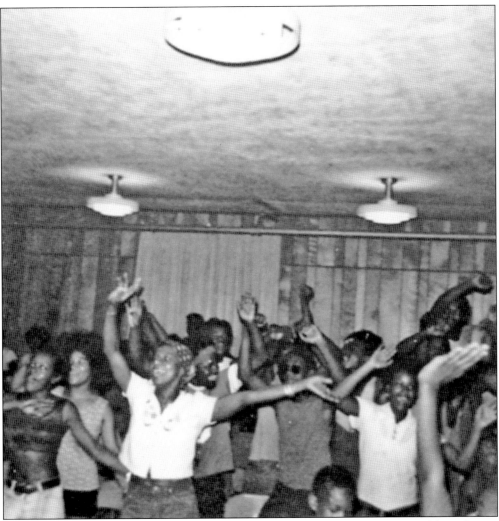

ELECTION NIGHT CELEBRATION. Many in the African American community celebrated upon hearing the news of the hugely successful election of their first majority black council. The victory party took place on election night, June 12, 1973, in the basement of First Baptist Church on Harrison Street. (Courtesy of Dr. Florence Farley.)

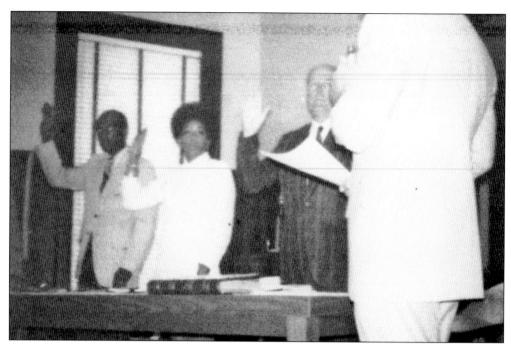

SWEARING IN THE FIRST MAJORITY BLACK COUNCIL. In July 1973, the city clerk swore in the first majority black city council for the first time. Pictured from left to right are black councilmembers Rev. Clyde Johnson and Dr. Florence Farley. (Courtesy of Dr. Florence Farley.)

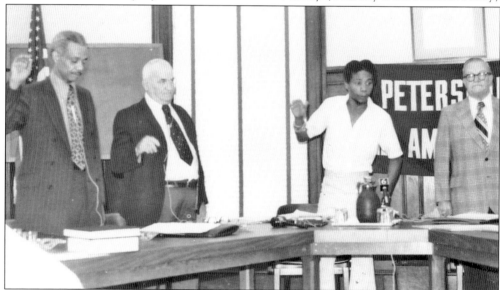

THE FIRST MAJORITY BLACK COUNCIL GETS TO WORK. Soon after being sworn in, the new majority black council attempted to implement changes in council procedure and policies to make government more responsive, accessible, and transparent for residents. One of their first major changes was to set aside a public comment period prior to all council meetings to provide residents an opportunity to voice their concerns, a practice still in use today. Shown are black councilmembers Mayor Hermanze Fauntleroy (left) and Roy Hines (center). (Courtesy of Dr. Florence Farley.)

DR. FLORENCE S. FARLEY. Dr. Farley was elected to the Petersburg City Council in 1973, making her the first woman to serve in that capacity. In 1984, Farley became the first woman to serve as mayor of Petersburg and the first black woman mayor of a Virginia city. Dr. Farley was the first black clinical psychologist licensed by examination in Virginia and was the first black clinical psychologist to work at Central State Hospital. Farley was also a professor of psychology for over 40 years at Virginia State University and chaired the psychology department for several years. (Courtesy of Dr. Florence Farley.)

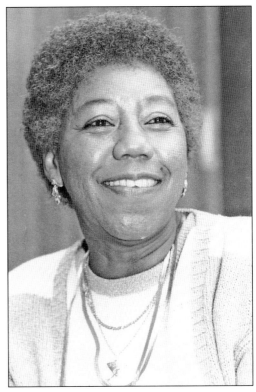

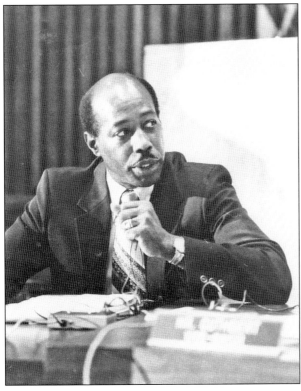

REV. CLYDE JOHNSON. Johnson was elected to Petersburg's first majority black city council in 1973. He served on council for 13 years. A native of Durham, North Carolina, Johnson came to Petersburg as the pastor of First Baptist Church on Harrison Street. (Courtesy of the *Richmond Times Dispatch*.)

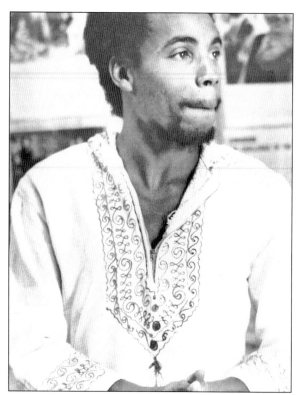

ROY "OMOWALE" HINES. In 1973, at the age of 25, Roy "Omowale" Hines became one of the youngest members in the city council's history. During his tenure on the council, Hines introduced a successful resolution that made Petersburg one of the first Virginia localities to condemn U.S. involvement in apartheid South Africa and to censure a local bank (United Virginia Bank) when it refused to divest its holdings in the country. He also championed a successful resolution to make Petersburg one of the first cities in the nation to make Dr. Martin Luther King's birthday an official city holiday. Hines served on the city council until May 1974. (Courtesy of Lloyd Hines.)

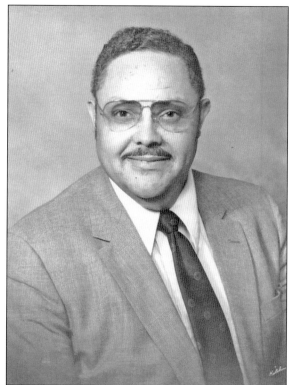

JACK BOND, THE FIRST BLACK CITY MANAGER. In 1979, Jack Bond became the first African American to be appointed by the city council as city manager. He served until 1984. (Courtesy of the City of Petersburg.)

Six

The Heyday of Black Business

Entrepreneurialism has long been a hallmark in Petersburg's African American community. From slavery to the era of Jim Crow segregation, to own a business meant greater independence and an ability to flourish despite repressive laws and practices. These businesses offered vital services and goods to both African Americans and the broader community. Their owners were often civic leaders who contributed funds, meeting spaces, and other resources to support black churches and other community goals.

During slavery's era, free blacks in Petersburg were resourceful and found ways to own numerous independent businesses. As early as 1815, free blacks in Petersburg such as Richard Jarratt, John Updike, and James Roberts worked as boatmen and fishermen. There were also shop owners like W. S. Harrison and George A. Farley, who co-owned a grocery in 1860 on Second Street on Pocahontas Island, and P. Cummings and Lucy Williams, who owned stores on Pocahontas Island at Main Street and Corling Street respectively.

The tradition of entrepreneurialism only grew. On February 5, 1936, Prof. Luther P. Jackson of Virginia State College began the Petersburg Negro Business Association to encourage the patronage of Petersburg's black-owned businesses and to promote good and effective business practices among black storeowners. Under the association's slogan "Share your trade with Negroes," members attended workshops at Virginia State on business practices, and they advertised to and dialogued with citizens through mailers and meetings.

Petersburg's largest concentration of black-owned businesses was located on the renowned "Avenue" or Halifax Triangle district. Although the area also had businesses that were not black owned, such as the popular O. P. Hare Drug Store, numerous black-owned restaurants, clubs, and doctors' offices, and their customers called the Avenue home. Most notable may be J. M. Wilkerson's Funeral Home, established in 1874. Wilkerson's proudly describes itself as being the oldest continuously operating black-owned business in Virginia.

The following images are a sample of the many African American–owned businesses that have called Petersburg home.

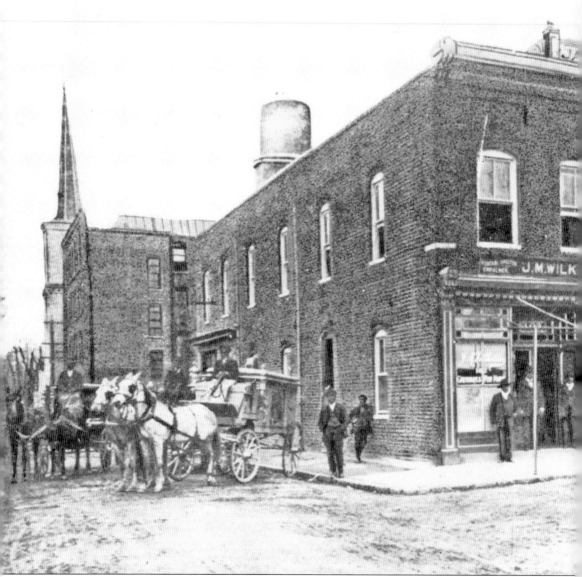

J. M. Wilkerson Funeral, Director and Liveryman. Established in 1874, this funeral home is believed to be Virginia's oldest continuously operating black-owned business. James M. Wilkerson Sr. was a carpenter called upon from time to time to make wooden coffins. This work resulted in Wilkerson beginning a funeral and livery service. The business began in the 100

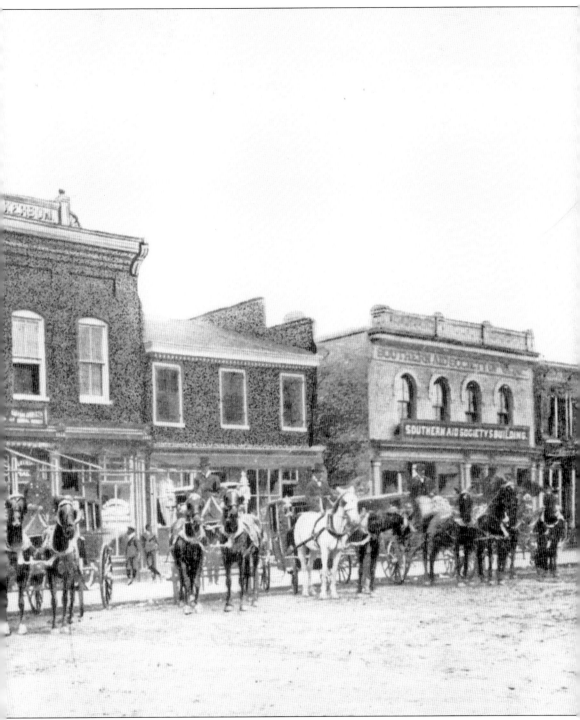

block of Harrison Street. It moved to its new location after it was taken over by J. M. Wilkerson II in 1890. The junior Wilkerson was the first black licensed embalmer in Virginia. Above is an early photograph of the thriving establishment. It shows the Wilkerson building surrounded by the business's numerous horse-drawn carriages. (Courtesy of Russell Wayne Davis.)

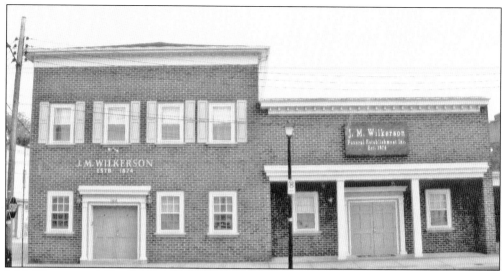

J. M. Wilkerson's Funeral Home in 2008. Today, in its same location since 1890, Wilkerson's continues to thrive in the funeral business and is a shining example of long-term black business success. (Courtesy of Amina Luqman-Dawson.)

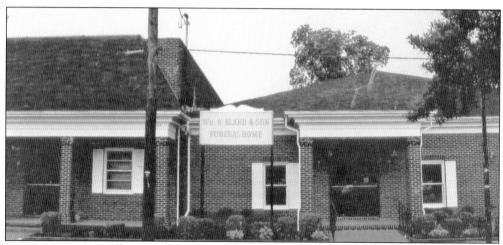

William N. Bland and Son Funeral Home in 2008. Established in 1952, this black-owned business became an institution in the Halifax Triangle area at 137 Harrison Street. Beyond offering funeral services, this business has a history of civic engagement. During the civil rights movement, the business contributed precious resources such as meeting space for activists and funds to assist in movement activities. (Courtesy of Amina Luqman-Dawson.)

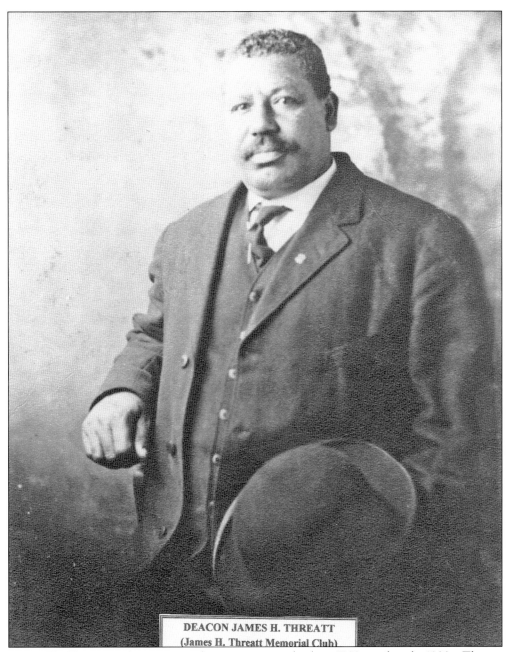

DEACON JAMES H. THREATT
(James H. Threatt Memorial Club)

JAMES H. THREATT. A prominent businessman in the late 1800s and early 1900s, Threatt owned a popular Petersburg fish market and numerous properties on Pocahontas Island. As a landowner, he created opportunities for poor blacks to inexpensively rent houses. It was not uncommon for Threatt to use his wealth for the betterment of his church, First Baptist, or for a host of other civic ventures in the African American community. He resided with his wife, Rosa L. Threatt, at 144 Main Street on Pocahontas Island. (Courtesy of First Baptist Church.)

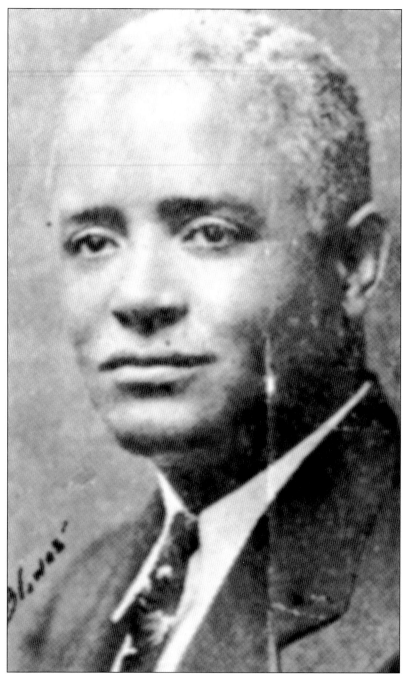

LUTHER PORTER JACKSON, CHAIRMAN OF THE PETERSBURG NEGRO BUSINESS ASSOCIATION. Jackson was a professor of history at Virginia State College and author of numerous books on African Americans in Petersburg. On February 5, 1936, Jackson began the Petersburg Negro Business Association to encourage the support of black-owned businesses and promote good business practices among black proprietors. By late 1937, the Petersburg Negro Business Association had 29 members. The association's slogan was "Share Your Trade with Negroes." (Petersburg Negro Business Association pamphlet, courtesy of Wayne Crocker.)

FLOYD JACKSON, GROCER. In 1937, Jackson was a grocer with an establishment located at Rome Street and Dunlop Street. He was a member of the Petersburg Negro Business Association. (Petersburg Negro Business Association pamphlet, courtesy of Wayne Crocker.)

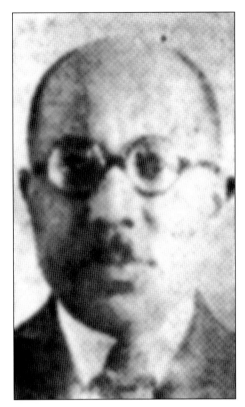

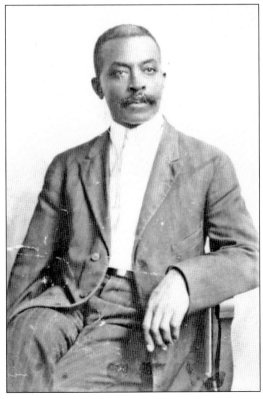

FRANK BATTS, GROCER. A founding member of Zion Baptist Church, Batts owned a grocery on Jones Street in 1937. He was a member of the Negro Business Association. (Courtesy of Zion Baptist Church.)

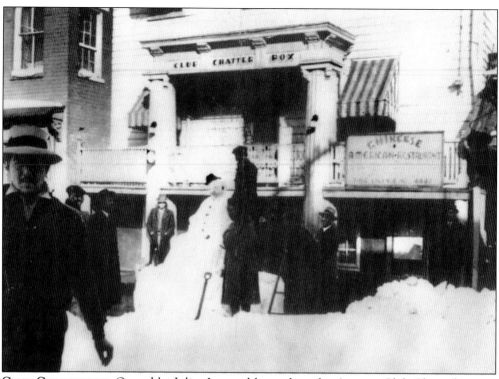

CLUB CHATTERBOX. Owned by Julius Lee and located on the Avenue, Club Chatterbox was one of the area's most popular clubs. Pictured here is the club on a snowy day. (Courtesy of the City of Petersburg).

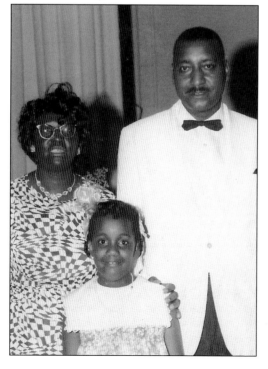

MR. WILLIAM A. WYCHE AND MRS. CATHERINE RUFFIN WYCHE, ENTREPRENEURS. The Wyches were the proprietors of two well-known businesses: Wyche's Confectionary (1958–1972) at 315 Halifax Street and Wyche's School of Childhood Kindergarten and Child Day Care Center (1954–1995) at 317 Halifax and later at 1009 Halifax. The confectionary was the only black-owned grocery in Petersburg in its time. Mr. Wyche began as a store employee and later worked to purchase it from its Jewish owners. The location soon became a gathering place for the area. Neighborhood residents would buy groceries, and gentlemen would would stand under the store's street light and trade news and gossip. Mrs. Wyche established and ran Wyche's School. It was known for educating and caring for thousands of Petersburg youngsters during its 41-year existence. The Wyches are pictured with their daughter Stardina L. Wyche. (Courtesy of William Wyche Jr.)

JOHN AND BERNICE'S CONFECTIONARY ("J&B's"). John H. Hill Jr. and and his wife, Bernice K. Hill, were the proprietors of John and Bernice's Confectionary. After church each Sunday, churchgoers would flood the Avenue and into the confectionary. They would be treated to restaurant specialities such as fresh apple pie and ice cream sundaes. The establishment was open until 1966. (Courtesy of John H. Hill III.)

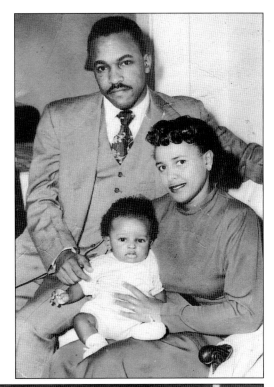

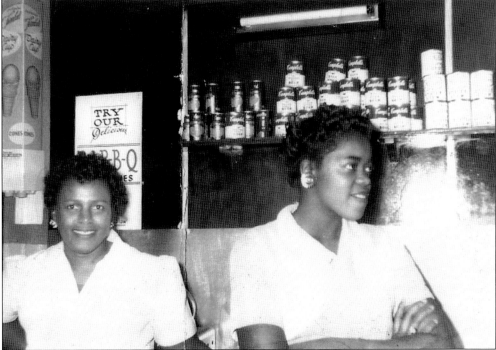

INSIDE J&B'S. When customers came to J&B's, they often requested their hamburger. It was the most popular menu item and was made to order by owner Bernice Hill, pictured here on the left with one of the restaurant's servers. (Courtesy of Judy Hill French.)

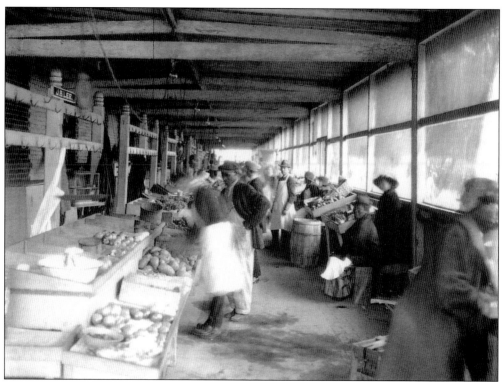

NEW MARKET COMES TO LIFE. On Saturdays, farmers traveled from as far as North Carolina to Petersburg's New Market to sell their produce. Pictured here are merchants and customers buying and selling their goods. (Courtesy of the City of Petersburg.)

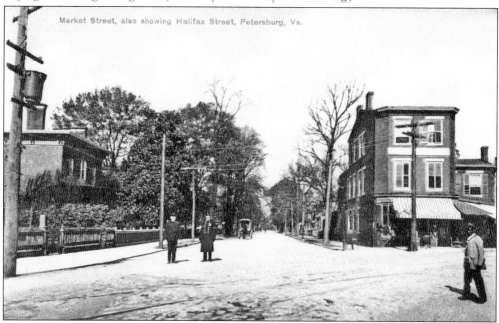

MARKET STREET AND HALIFAX STREET. This view shows a corner of Petersburg's Halifax Triangle area in the early 1900s. (Courtesy of Russell Wayne Davis.)

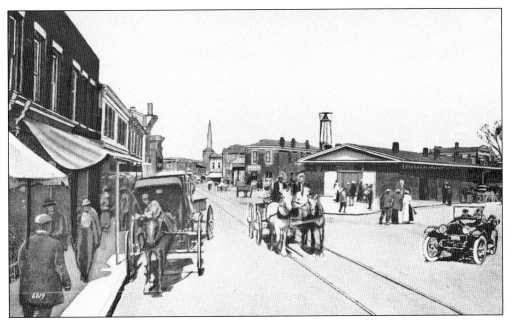

HALIFAX STREET SHOWING NEW MARKET. This 1920s view shows New Market. For decades, this was a popular open-air marketplace for local farmers, butchers, and artisans to sell their goods. (Courtesy of Russell Wayne Davis.)

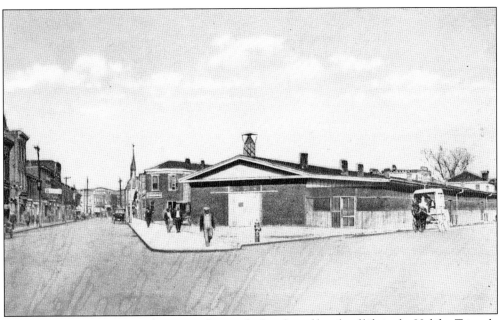

A VIEW OF NEW MARKET. This image depicts the hustle and bustle of life in the Halifax Triangle business district. Shoppers walked and rode in horse-drawn carriages and cars to the Halifax Triangle to do their shopping, dining, and socializing. (Courtesy of Russell Wayne Davis.)

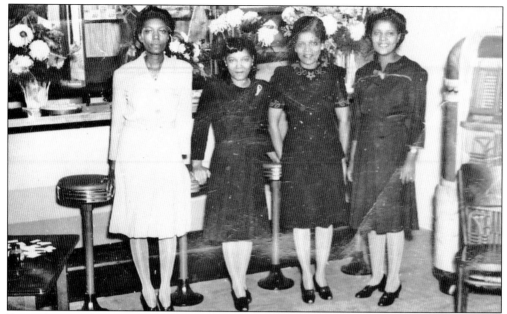

FOUR SISTERS OPEN BECKY'S COFFEE SHOP. In 1942, four Butcher sisters joined together to open Becky's Coffee Shop. The sisters, (from left to right) Alice Butcher Jones, Gertrude Butcher Edwards, Agnes Butcher Morgan, and Ruth Butcher Royall, named the restaurant after a fifth sister, Rebecca Butcher Prout, who was residing in New Jersey at the time. The four sisters were all teachers and graduates of Virginia State College and shared in the responsibilities of running the business until it closed 10 years later. (Courtesy of Alice Butcher Jones.)

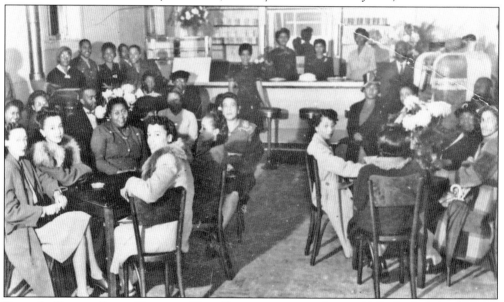

BECKY'S COFFEE SHOP, OPENING DAY. From its opening day in 1942, Becky's Restaurant, located at the corner of Halifax and Gill Street, was known for using high-quality foods and serving favorites such as hamburgers, fried chicken and waffle dinners, pies, and other baked goods. The restaurant was visited by famous greats such as Count Bassie, Duke Ellington, and Billie Holiday. (Courtesy of Alice Butcher Jones.)

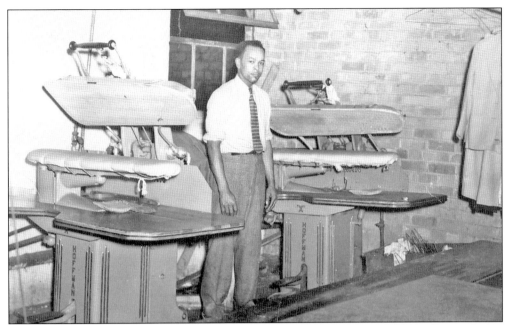

OWENS'S CLEANING AND TAILORING. Joseph Owens, a native of North Carolina, came to Petersburg, where he attended Virginia State College for Negroes and earned a certificate in tailoring. He worked at the Old Trench Cleaning and Pressing Shop. By 1942, using his earnings, Owens opened Owens's Cleaning and Tailoring, a dry cleaning service located at 250 Halifax Street. Owens also participated in city politics and became the first African American elected to Petersburg's city council since Reconstruction. (Courtesy of Juanita Owens Wyatt.)

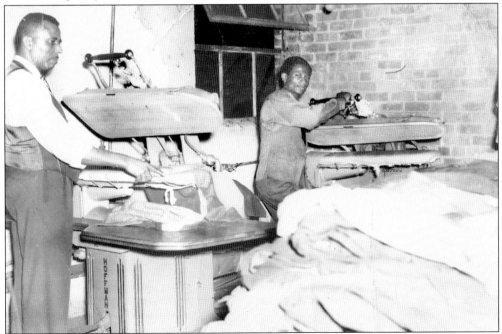

WORKERS AT OWENS'S CLEANING AND TAILORING SHOP. Here workers at Owens's Cleaning and Tailoring press the day's laundry. (Courtesy of Juanita Owens Wyatt.)

Dr. Thomas Baugh, M.D. A native of Petersburg, Baugh graduated from Virginia State College for Negroes and completed medical school at Howard University before returning to Petersburg. In 1952, Baugh became one of the first black doctors on the staff of Southside Regional Hospital. He was on staff until 1993. Also in 1952, Baugh opened his practice at South Avenue and Halifax Street over O. P. Hare Drug Store. He later relocated to the corner Sycamore and Tabb Streets. Dr. Baugh practiced until 2002. (Courtesy of Dr. Thomas Baugh.)

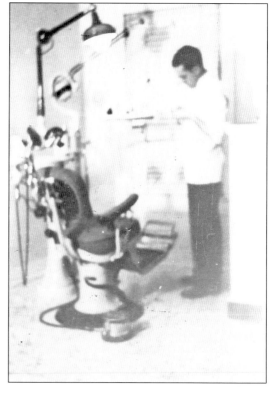

Dr. Granville Norris. A Petersburg native and son of Mr. and Mrs. Fleming H. Norris, Dr. Norris was a civic leader, church worker, and activist for public school education. After graduating from Peabody High School, he studied at Virginia Union University. He transferred to and graduated from Virginia State College. A 1940 graduate of the Howard University dental college, Dr. Norris practiced in Petersburg from January 1941 until his death on September 15, 1988. (Courtesy of Ethel Norris Haughton.)

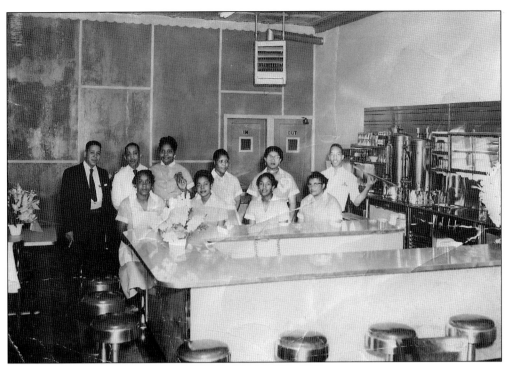

FARLEY'S RESTAURANT. Richard Farley (far left) inherited his restaurant from his father, Alexander P. Farley. The restaurant, which was in business for over 50 years, was located on the popular Avenue. It was known for having great beef stew and corn bread. Farley was a civic-minded businessman; as a bonus each year, he purchased shoes and books for his employees' children at the beginning of the school year. (Courtesy of Dr. Florence Farley.)

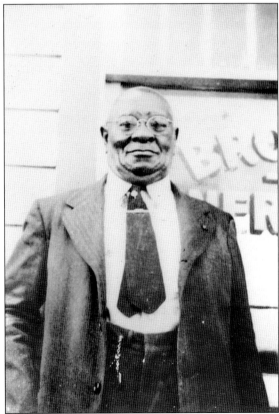

THOMAS H. BROWN, UNDERTAKER. Brown was born in 1874 in Alexandria, Virginia, where he owned a funeral parlor. He later moved to Petersburg and opened an undertaker establishment at 301 Gill Street (Farmer Street today). For over 50 years, Thomas Brown was also the caretaker of the city's historic People's Cemetery. He helped ensure the upkeep of the grounds and maintained maps of tombstone locations. (Courtesy of Thomasine Burke.)

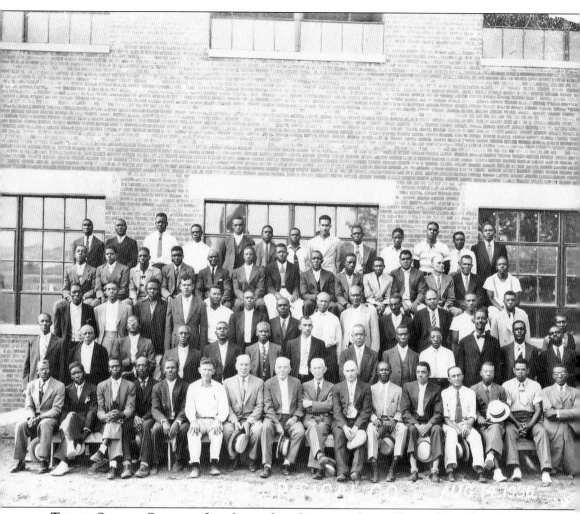

TITMUS OPTICAL COMPANY, INC. Located on Commerce Street, Titmus Optical is a longtime manufacturer of eyeglass frames, lenses, and ophthalmic instruments. Although Titmus Optical is not black-owned, it was a large employer of African Americans in the early 20th century. Among the many men employed in 1936 were John Hampton Brown Sr. (first row, seated fifth from right) and Willie Powell (third row, fourth from left). (Courtesy of William H. Brown.)

Seven
THE POWER OF KNOWLEDGE

Education has been a hallmark of the African American community in Petersburg. Well before the end of the Civil War, free blacks in Petersburg employed tutors such as Joseph Sheppard to visit their homes and provide private instruction. In addition, residents like Collier Tabb and Fannie Colson established and operated small, informal schools and insured the education of Petersburg's African Americans despite white mainstream opinions and restrictive laws.

At slavery's end, racial segregation permeated all facets of life in Petersburg; education was no exception. Black schools always received fewer resources and served larger numbers of students than their white counterparts. In spite of this, educational institutions for black students became sources of academic excellence that propelled countless students to higher education and professional careers.

From the 1950s to the 1970s, educational life for most of Petersburg's black children began at Wyche's School of Childhood Kindergarten and Child Day Care Center. Under the direction of Catherine Wyche and teachers like Isaphine Griffin, students learned their letters and numbers as well as the importance of being well mannered and receiving a good education.

Black elementary school children attended one of three schools: Blandford Elementary, Virginia Avenue Elementary, or Westview Elementary. The teachers and administrators of these schools worked tirelessly to produce well-rounded students, teaching not only academics, but also instilling a sense of culture, art, and civic pride. It was not unusual for students to learn and perform grand plays and shows. For example, at the Virginia Avenue School, in 1940, the students performed the operetta "A Rose Dream." In these schools, student choirs, student councils, and a variety of other activities contributed toward producing high-quality students.

Regardless of where you lived in Petersburg, until the late 1960s, if you were a black high school student in Petersburg, you likely attended Peabody High School, the oldest public high school for African-Americans in Virginia. In its heyday, Peabody was a thriving academic center, with students participating in numerous clubs, school bands, and athletic teams. The school was known for having one of the area's best football teams. These dynamic students helped change life in Petersburg and were at the forefront of the civil rights movement. Their picketing and protests contributed to the desegregation of businesses in Petersburg.

The following compilation of images shows students and life in some of Petersburg's most beloved African American schools.

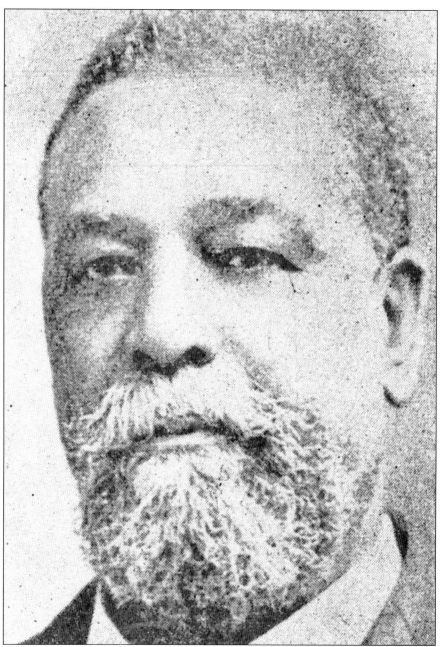

HENRY WILLIAMS. Reverend Williams was pastor of the historic Gillfield Baptist Church from 1865 to 1900. Beyond being a respected pastor, he left behind a legacy of political activism through his service on city council during Reconstruction and his leadership in promoting policies and practices for the betterment of African American schools. Williams is credited with mobilizing community members in 1869 to petition for the hiring of black teachers and administrators to serve in the city's African American schools. Until that time, black children in public schools were educated by whites. After repeatedly petitioning the board of education, the committee was successful, and the practice was finally changed in 1882. (Courtesy of Negro Office Holders in Virginia.)

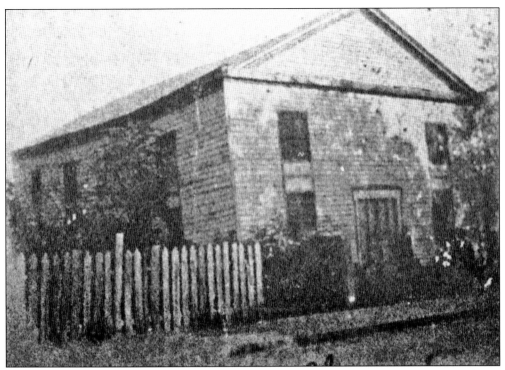

OLD AFRICAN CHURCH. In January 1870, the Old African Church became the site of Petersburg's first black public high school. The school opened with 50 high school and elementary students, four teachers, and Principal Giles Buckner Cooke. Peabody High School developed out of the Old African Church school. (Courtesy of the Peabody High School Centennial Calendar.)

PEABODY-WILLIAMS SCHOOL. In 1915, the school board proposed the construction of two connected school buildings on Jones Street. The Peabody Building, named for the philanthropist George Peabody, would serve as the high school. The Williams Building, named for Henry Williams, would be the middle school. The two buildings successfully opened in 1920. The Peabody Building could hold 350 students, and by the 1921–1922 school year, it was a fully accredited four-year high school. (Courtesy of the Peabody High School Centennial Calendar.)

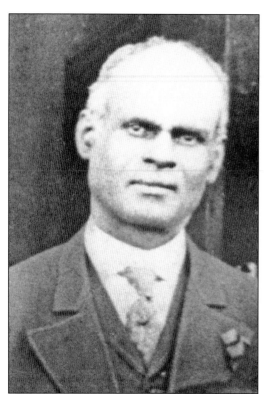

JAMES E. SHIELDS. Shields served as principal of Peabody High School for 46 years (1889–1935). Shields, born in Petersburg in 1867, graduated from the Virginia Normal and Collegiate Institute. He was both a teacher and principal at Bishop Payne Normal School for two years before becoming principal of Peabody High School. At the time of his death in 1957, Shields was a highly respected member of the community. (Courtesy of the Peabody High School Centennial Calendar.)

ELMORE RAINEY, FIRST BLACK ASSISTANT SUPERINTENDENT. Rainey served as principal of Peabody High School from 1961 to 1971. Rainey is credited with showing great leadership by bringing Peabody High School into compliance with *Brown v. Board of Education*. Rainey went on to become the first black assistant superintendent of Petersburg schools. (Courtesy of the Peabody High School Centennial Calendar.)

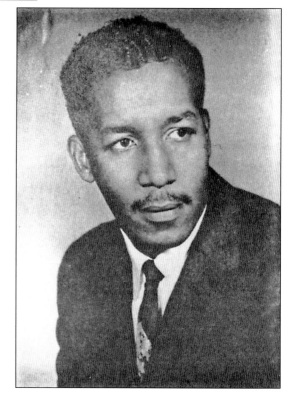

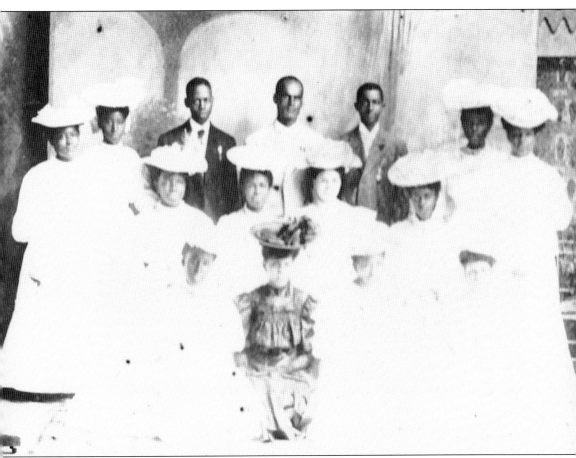

PEABODY HIGH SCHOOL GRADUATING CLASS OF 1906. Proud students of Peabody High School's class of 1906 pose for their graduation picture with Principal Shield. (Courtesy of Grace Townes.)

PEABODY HIGH SCHOOL DOMESTIC ART CLASS, 1920. Peabody High School offered a well-rounded curriculum that included the domestic arts. (Courtesy of the Peabody High School Centennial Calendar.)

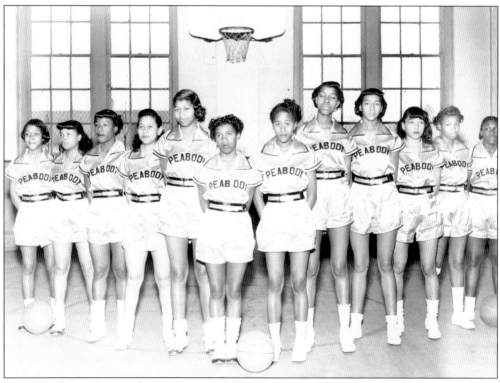

PEABODY HIGH SCHOOL GIRL'S BASKETBALL TEAM, 1950. The Lionettes were the season and district champions from 1950 to 1953. (Courtesy of Mattie Watson Powell.)

WYCHE'S SCHOOL OF CHILDHOOD KINDERGARTEN AND CHILD DAY CARE CENTER, SCHOOL BUILDING. Wyche's School opened in 1954 on the first floor of Mr. and Mrs. William and Catherine Wyche's home at 317 Halifax Street. In 1961, the Wyche's School moved to 1009 Halifax Street (pictured) to a building formerly used as a church parsonage. Mrs. Wyche operated the school for 41 years. Wyche's was the only school of early education for black children; If you were black in Petersburg and born between the 1950s and 1970s, you attended Wyche's School. (Courtesy of William Wyche Jr.)

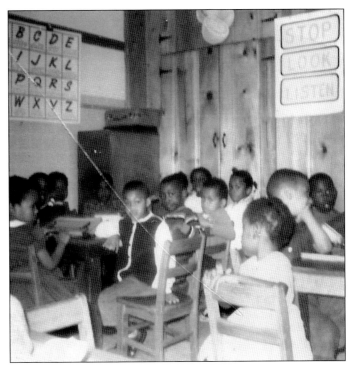

WYCHE'S SCHOOL CLASSROOM. Students sit at their desks in a Wyche's School classroom at 317 Halifax Street. The superintendent of Petersburg School once commented that you could always tell students that came from Wyche's School. The school was known for producing both well-behaved and well-learned students. (Courtesy of William Wyche Jr.)

WYCHE'S SCHOOL GRADUATION, CLASS OF 1961. It is graduation day for kindergarten students at Wyche's School. Here the students sit at attention during their graduation ceremony held at Harding Street Recreational Center. With the students is longtime teacher Isaphine Griffin (left) and organist Bernice Morgan. (Courtesy of William Wyche Jr.)

WYCHE'S SCHOOL GRADUATION, CLASS OF 1963. Pictured are students from Wyche's School at their graduation-day ceremony held at Harding Street Recreational Center. The students on the left are are rising preschoolers, while the students in robes are the graduating kindergarteners. Principal and school founder Catherine Wyche (front) is directing the program with teacher Isaphine Griffin and oraganist Bernice Morgan (right). (Courtesy of William Wyche Jr.)

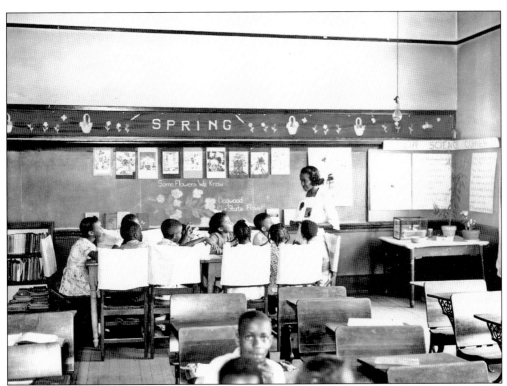

BLANDFORD ELEMENTARY SCHOOL, MAY 1946. Students are pictured during a classroom lesson at historically black Blandford Elementary School. (Courtesy of City of Petersburg Museums.)

BLANDFORD ELEMENTARY SCHOOL, APRIL 1946. Students sit at attention in Blandford Elementary School. (Courtesy of City of Petersburg Museums.)

VIRGINIA AVENUE SCHOOL, 1950 STUDENT CHOIR. The Virginia Avenue School was established in 1930 to relieve overcrowding in the Henry Williams School on Jones Street. Upon opening, the school had 138 enrolled students and two teachers. Here in 1957, members of the student choir pose with longtime principal Gwendolyn Jones (right). The students have just completed a performance for the parent-teacher association. (Courtesy of the Virginia Avenue Elementary School Archives.)

VIRGINIA AVENUE SCHOOL, 1954 SAFETY PATROL. Pictured are the students of the 1954 Safety Patrol. A program administered by AAA, the students were trained in street safety. A highly respected student position, the patrols would assist students in crossing the street and ensure the safety of students as they departed at the end of the school day. The students are shown with their teachers, Ida Allen (far left), Deana Abbott Freeman (second from the right), and Ola Edmonds (far right). (Courtesy of the Virginia Avenue Elementary School Archives.)

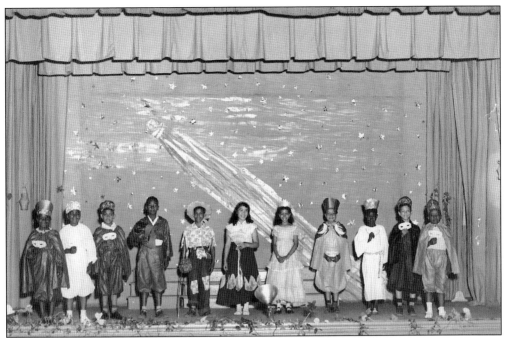

VIRGINIA AVENUE SCHOOL, 1953 STUDENT PERFORMANCE. Each year, the students of Virginia Avenue created and performed a program for parents and community members. Here the students take a final bow at the conclusion of their 1953 performance held in the Virginia Avenue School auditorium. (Courtesy of Virginia Avenue Elementary School Archives.)

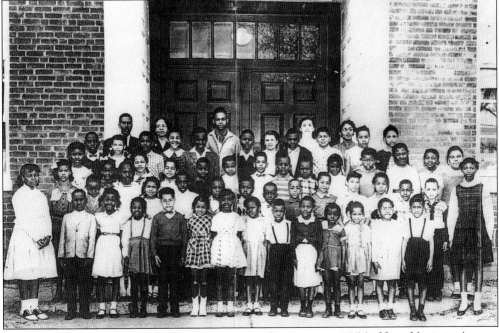

VIRGINIA AVENUE SCHOOL'S FIRST STUDENT COUNCIL IN 1956. Here Virginia Avenue School's first student council poses for a portrait in front of the school building. (Courtesy of Natalie G. Hill.)

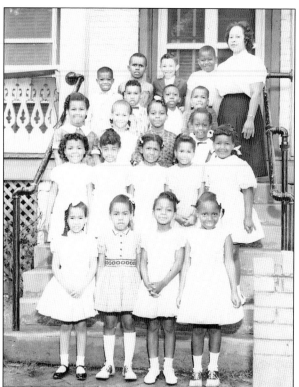

MARIAN REID OF FIRST BAPTIST CHURCH OPENS A SCHOOL. In 1960, Marian Reid, wife of Rev. Milton A. Reid of First Baptist Church, opened a small school to educate her child and other neighborhood children. Her class is pictured here in front of the First Baptist parsonage, the site of the school. The school was open for one year. (Courtesy of Dr. Milton and Marian Reid.)

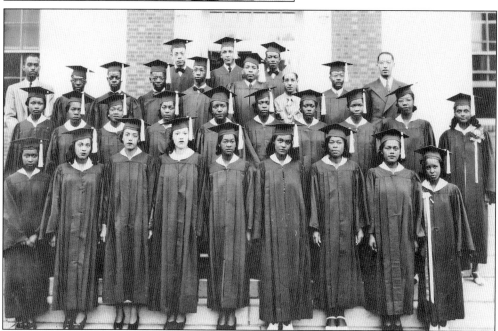

D. WEBSTER DAVIS LABORATORY HIGH SCHOOL GRADUATING CLASS OF 1942. Virginia State College's laboratory high school provided Petersburg students not only with a traditional curriculum, but also with training in valuable trade skills. Posed here are the graduates of Davis High School's class of 1942. (Courtesy of William H. Brown.)

Eight
IN SERVICE OF COMMUNITY

An essential part of Petersburg's African American history is located in the valuable work of its civic organizations. Within these social clubs, fraternities, sororities, and political organizations, African Americans of Petersburg come together to enjoy and celebrate one another and pool their resources and ideas to positively contribute to the community. Their efforts have resulted in the provision of essential volunteer services, planning and execution of social and cultural events, and organizing charitable works that serve Petersburg's youth, elderly, and everyday citizens.

The long and deep history of African American civic organizations in Petersburg is incomparable to that of almost any other Virginia city. The city boasts one of the oldest chapters of Masons in the Masonic 12th District, the oldest chapter of Alpha Kappa Alpha Sorority in the mid-Atlantic region, and the fifth-oldest chapter of the Links in the nation, begun only three years after the first chapter was organized.

Presented here is a small sampling of Petersburg's numerous civic organizations and leaders. In some cases, the images show both past and present organizational membership.

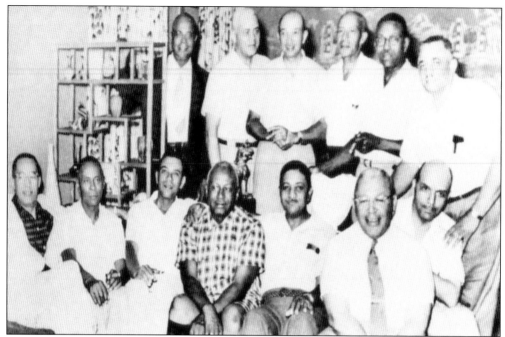

CLUB TWENTY, INC. Club Twenty was begun in 1938 by a group of 20 black men. It was comprised of area professionals, including doctors and lawyers. In 1964, the club merged with the Beaux Social Club to become the Beaux Twenty Club, Inc. Pictured are members of the early Club Twenty. Their clubhouse was the former USO at 464 Byrne Street. (Courtesy of the Beaux Twenty Club Inc.)

THE BEAUX SOCIAL CLUB. The Beaux Social Club began in 1959 to provide a social and civic space for younger men, in part because Club Twenty tended to cater to the interests of older men. The Beaux Social Club, Inc., took its name from Beau Brummel, the French arbiter of men's high fashion in Regency England. Pictured here are some of the club's early members. In 1964, the club merged with Club Twenty to form the Beaux Twenty Club, Inc. (Courtesy of the Beaux Twenty Club Inc.)

CLUB WIVES AT A BEAUX SOCIAL CLUB EVENT. Pictured are the elegantly dressed wives of the Beaux Social Club at a club event in the early 1960s. (Courtesy of the Beau Twenty Club, Inc.)

BEAUX TWENTY EXECUTIVE BOARD, 2008. Pictured from left to right are Dr. Howell T. Jones, Bernard Lundy, Sherman Hudson, Louis F. Martin, Joseph P. Dickens (president), Dave Liggins Jr., Roosevelt Washington, Hermanze E. Fauntleroy, James R. Clark, and Russell L. Bland. (Courtesy of the Beaux Twenty Club Inc.)

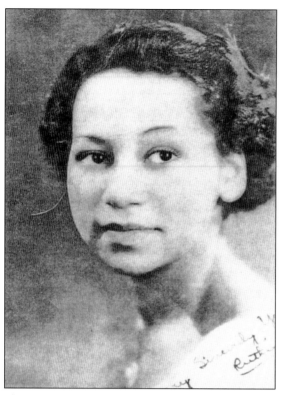

RUTH GOLDEN COOLEY. Ruth Cooley, wife of attorney Robert H. Cooley Jr., organized the Junior Civic League Club in 1938. In existence for over 70 years, the club stresses responsible civic action for African American women, community service, and economic self help and provides care and assistance to the needy, family counseling, education, and scholarship assistance to youth. (Courtesy of Iris Brown.)

JUNIOR CIVIC LEAGUE MEMBERS IN 1981. From left to right are (first row) Elsie Galloway, Ernestine Batts, Alice Coles, Evelyn Pegram, and Sadie McCoy; (second row) Juliette Turner, Viola Chavis, Ethel Cain, Martha Dance, Josephine Jones, Bettie James, Poly Redd, Annabel Patterson, and Ruth Royall; (third row) Ethel Greene, Katie Walker, Ella Morgan, Bettie Lanier, and Marie Jones. (Courtesy of Iris Brown.)

JUNIOR CIVIC LEAGUE MEMBERS, 1998. Members celebrate the 60th anniversary of the Junior Civic League, established in 1938 by Ruth Golden Cooley. (Courtesy of Iris Brown.)

HALO GRACE DRAMATIC CLUB. Once located on Halifax Street, the Halo Grace Dramatic Club was a steward of the dramatic arts in Petersburg. The late Ethel Williams, wife of Robert Williams, is second from left in the second row. (Courtesy of Robert Williams.)

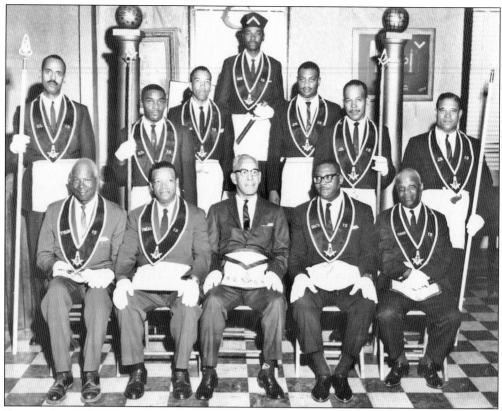

EUREKA LODGE NO. 15 OF THE 12TH MASONIC DISTRICT PRINCE HALL MASON PETERSBURG, C. 1970. Located at 1204 Halifax Street, the Eureka Lodge No. 15 is one of the oldest in the 12th Masonic District. The lodge's officers are picture in this 1970s-era image. (Courtesy of Willis and Iris Brown.)

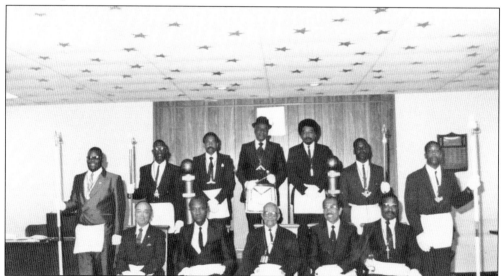

EUREKA LODGE NO. 15 OF THE 12TH MASONIC DISTRICT, 1980S. Officers of the lodge are seen in this late-1980s-era image. (Courtesy of Willis and Iris Brown.)

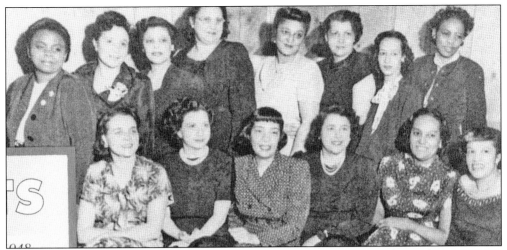

THE LINKS, INC., PETERSBURG CHAPTER. The fifth chapter of the Links in the nation was established on May 7, 1948, in Petersburg with the induction of 14 charter members. The charter members pictured here from left to right are (first row) Uarda Parnell, Evelyn Jenkins, Adelaide White, Virginia Williams, Susie Verdell, and Gladys Green; (second row) Ruth Baker, Josephine Jones, Marietta Cephas, Doris Reynolds (from the Philadelphia chapter), Alma Brown, Eunice Robbins, Helen Williams, and Cleopatra Armstrong. (Courtesy of the Links, Inc., Petersburg Chapter.)

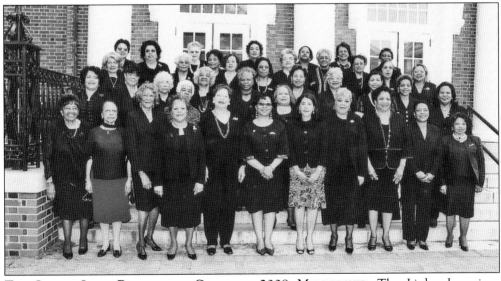

THE LINKS, INC., PETERSBURG CHAPTER, 2008 MEMBERSHIP. The Links, Inc., is a volunteer service organization of concerned, committed, and talented women who, linked in friendship, enhance the quality of life in the larger community. (Courtesy of the Links, Inc., Petersburg Chapter.)

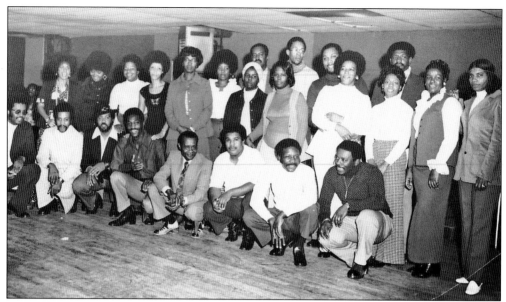

CLUB CHAR-LEMANZE 1978 MEMBERSHIP. Established in 1964, Club Char-Lemanze is a coed civic and social organization located at 901 Melville Street. (Courtesy of Club Char-Lemanze.)

CLUB CHAR-LEMANZE 2008 MEMBERSHIP. In addition to social events, Club Char-Lemanze sponsors a number of community activities, including annual Easter egg hunts, school supply giveaways, and contributions to Toys for Tots during the holiday season. They also have two annual scholarships for deserving high school students. (Courtesy of Club Char-Lemanze.)

ALPHA KAPPA ALPHA SORORITY, INC., DELTA OMEGA CHAPTER. The chapter was founded on February 6, 1921, on the campus of Virginia State University. It was the first AKA chapter in the mid-Atlantic region. The mission of the sorority is to provide service to all mankind. Their service embraces areas such as education, scholarships, healthcare, economic empowerment, family relations, political action, and the arts. Pictured are members from the 1960s. Two charter members are shown: Louise Stokes Hunter (second row, third from the left) and Edna Meade Colson (seated second from the right). (Courtesy of Alpha Kappa Alpha Sorority, Inc.)

ALPHA KAPPA ALPHA SORORITY, INC., DELTA OMEGA CHAPTER 2008 MEMBERSHIP. This annual membership photograph was taken in front of Zion Baptist Church. (Courtesy of Alpha Kappa Alpha Sorority, Inc.)

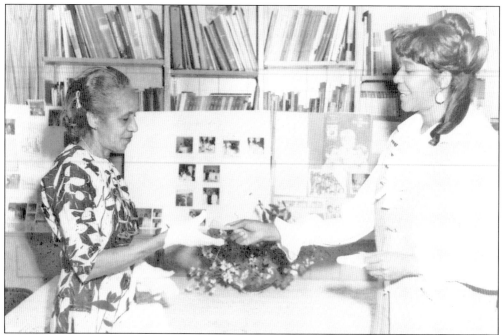

DELTA SIGMA THETA SORORITY, INC. Delta Sigma Theta is dedicated to volunteer public service in Petersburg and the broader community. Here Gertie Boothe Williams (right), president of the Delta Sigma Theta Petersburg Alumnae Chapter, presents Piccola Locket (left) of the Mary Carter Beacon House with a contribution to aid the visually handicapped. (Courtesy of Nancy Walden.)

DELTA SIGMA THETA SORORITY, INC. Pictured here is the 1985 May Week Committee. From left to right are (first row) Chanda Braggs and Roberta Pope-Matthews; (second row) Goldie Van Jackson, Thomila Wilson, Lynn Tyler, Angeline Brown, Jackie Randolph, and Nancy Walden. (Courtesy of Nancy Walden.)

DELTA SIGMA THETA SORORITY, INC., 2008 EXECUTIVE COMMITTEE. The rich tradition of Delta Sigma Theta continues. From left to right are (first row) Debra S. Jones, Lynn D. Cook, and Deidre R. Butts; (second row) Florence L. Rhue, Cheryl Brooks-Brown, Audrey N. Thrift, Nancy E. Walden, Gwendolyn F. Carney, Tamara G. Arnold, Loretta M. Braxton, and Ronda Edmonds. (Courtesy of Nancy Walden.)

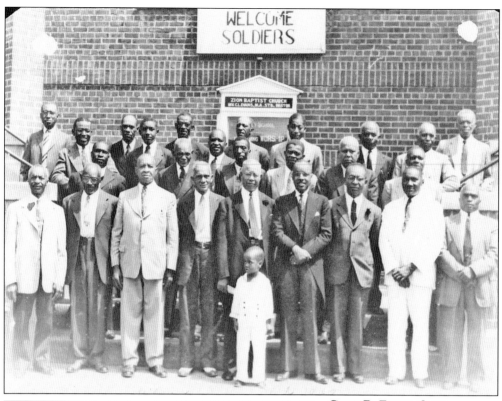

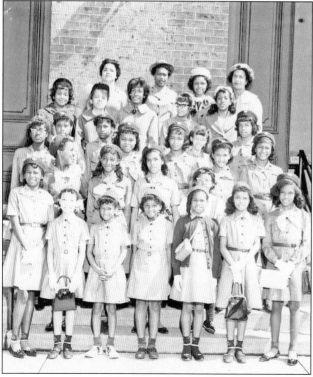

GILES B. EVANS CLUB, 1943 MEMBERSHIP. African American churches have always been significant locations for civic activity in Petersburg. The Giles B. Evans Club at Zion Baptist Church was established as a support for black soldiers returning from war and those stationed at Fort Lee. (Courtesy of Zion Baptist Church.)

GIRL SCOUTS AT GILLFIELD BAPTIST CHURCH. The Girl Scouts have been a great part of civic life in Petersburg. Here the scouts pose for a picture in the 1960s. (Courtesy of Gillfield Baptist Church.)

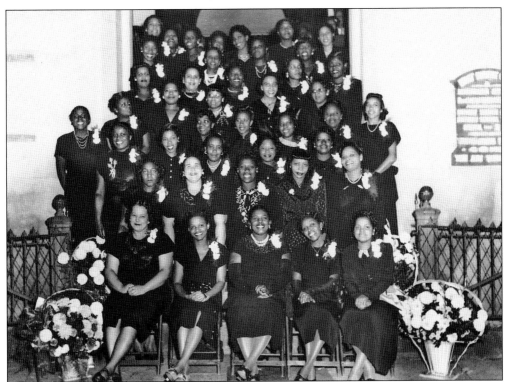

M. M. CLARK CIRCLE WOMEN'S CLUB AT FIRST BAPTIST CHURCH, HARRISON STREET. The church has always been a place to demonstrate civic participation. Here are members of the First Baptist Church's 1950s Women's Club. (Courtesy of Mattie Watson Powell.)

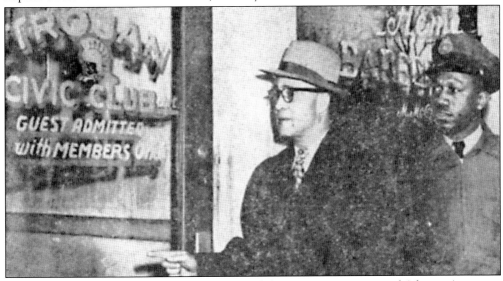

THE TROJAN CLUB. In the 1950s, the Trojan Club was an organization of African American skilled craftsmen and professionals. Among other things, the club dedicated itself to increasing African American voter representation. Trojan Club members sponsored voter registration drives and recognized individuals and churches for registering black voters. Pictured here is club member Charles Ballard (left) and Clarence Butcher (right). (Courtesy of Dr. Florence Farley.)

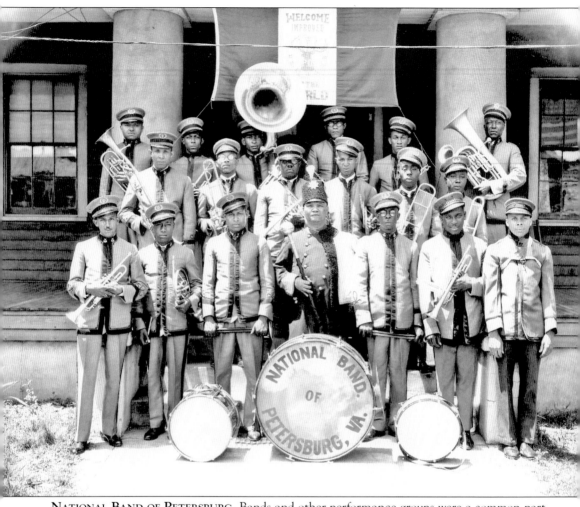

NATIONAL BAND OF PETERSBURG. Bands and other performance groups were a common part of civic life in Petersburg's African American community. They were often used at community functions and in holiday parades. Here the National Band of Petersburg stands in front of the Elk's Home around May 1935. (Courtesy of City of Petersburg Museums.)

Nine
People and Places of Note

Petersburg has been home to numerous African Americans who garnered local fame and many who have gone on to gain critical acclaim and recognition in the arts and sports. Here is a small sampling of notable people who have called Petersburg home and of places with special importance and meaning for the African American community.

AFRICAN AMERICAN WOMEN AT LEE PARK. In 1935, as part of Pres. Franklin Roosevelt's WPA, African American women were integral in the development of the Lee Park Wildflower and Bird Sanctuary. During the project, over 10 miles of path were made, and 38,000 shrubs, 8,000 trees, and over one million roots of honeysuckle were planted. (Courtesy of Tim Richard.)

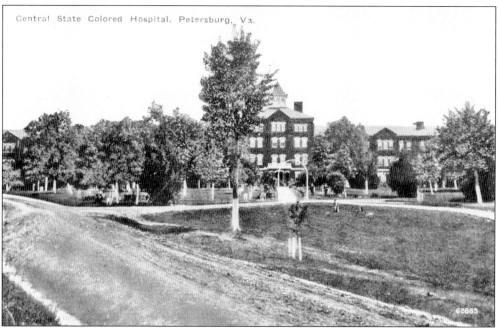

CENTRAL STATE HOSPITAL. Central State Hospital was established in 1865 by the Freeman's Bureau and was the first mental health hospital for blacks. The facility was originally known as Central Lunatic Asylum and was housed in Howard's Grove Hospital, a former Confederate facility. In 1885, Central State Hospital opened a new facility (pictured). From its founding until the passage of the Civil Rights Act of 1964, Central State Hospital was the only facility in Virginia to serve and treat only African Americans who were mentally ill, mentally retarded, geriatric, and criminally insane. (Courtesy of Russell Wayne Davis.)

SUSIE BOYD. Teacher and writer Susie Boyd worked as a federal writer for the Negro Federal Writers Project of Virginia. She interviewed ex-slaves in Petersburg. Her work was an invaluable contribution to chronicling the first-hand experiences of enslaved African Americans. (Courtesy of City of Petersburg Museums.)

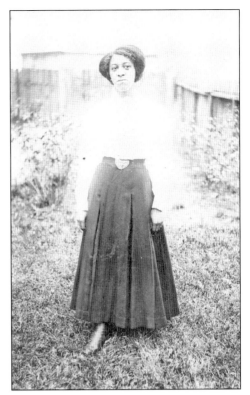

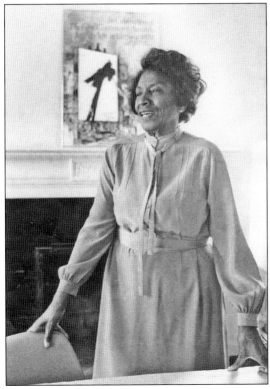

UNDINE MOORE, RENOWNED COMPOSER. Dr. Undine Moore was nominated for a Pulitzer Prize for her 16-part choral work "Scenes from the Life of a Martyr" in honor of Dr. Martin Luther King. Dr. Moore, a beloved professor, taught piano, organ, and music theory at Virginia State University. Several of her students went on to gain great acclaim as musicians, and countless others were forever inspired by her love of classical music. (Courtesy of the *Richmond Times Dispatch*.)

MOSES MALONE. A Petersburg native and local basketball phenom, Moses Malone grew up in the Delectable Heights neighborhood on St. Matthews Street. He was a graduate of Petersburg High School's class of 1974. Malone was the first player to join professional basketball right out of high school. Malone played for several teams including the Houston Rockets, Philadelphia 76ers, Washington Bullets, Atlanta Hawks, Milwaukee Bucks, and San Antonio Spurs. A marvelous rebounder, Malone was noted to have had the record for the most offensive rebounds in a season and the most in a career. After an illustrious career, Malone was inducted into the Basketball Hall of Fame. (Courtesy of the *Richmond Times Dispatch*.)

MOSES MALONE VISITS PETERSBURG. Moses Malone visits his neighborhood of Delectable Heights on September 1, 1974. (Courtesy of the *Richmond Times Dispatch*.)

BLAIR UNDERWOOD. The son of an army colonel, actor Blair Underwood lived in several places before settling in Petersburg. A graduate of Petersburg High School, he is pictured here in his 1985. Underwood was a popular student, involved in student government and numerous clubs. He went on to attend Carnegie Mellon University, where he studied dramatic arts. Underwood has flourished as a star of television and film in works such as *L.A. Law*, the HBO series *In Treatment* and *Sex and the City*, and the romantic comedy film *Something New*. Underwood made his directorial debut with the independent drama *Bridge to Nowhere*. (Courtesy of Petersburg High School.)

RICKY HUNLEY. A native of Petersburg, Hunley left the city for an illustrious career playing and coaching football. Hunley played in college for Arizona as a linebacker, and then went on to the National Football League where he played for the Denver Broncos, Phoenix Cardinals, and the Los Angeles Raiders. Hunley has gone on to serve as assistant coach for the Cincinnati Bengals. (Courtesy of the *Richmond Times Dispatch*.)

JUDGE ROGER L. GREGORY. A native of Petersburg, Judge Gregory graduated summa cum laude from Virginia State University in 1975 and from the University of Michigan School of Law in 1978. Gregory cofounded the law firm of Wilder and Gregory with former Virginia governor Lawrence Douglas Wilder. In 2000, Gregory was nominated by Pres. Bill Clinton to serve on the U.S. Court of Appeals, 4th Circuit, and was installed by recess appointment. He was renominated in 2001 by Pres. George W. Bush and confirmed by the Senate on July 20, 2001. Judge Gregory is the first black judge to ever serve on the 4th Circuit. He is also the only person in U.S. history to be appointed to the U.S. Court of Appeals by two presidents of different political parties. (Courtesy of Judge Roger L. Gregory).

JAMES BROWN AT HARDING STREET RECREATIONAL CENTER. During the heyday of the Avenue, the Harding Street Recreational Center became a favorite location to see local and nationally recognized black performers. In the early 1960s, a ticket to a James Brown performance only cost a quarter. Pictured here after a Harding Street performance are, from left to right, James Brown, Yvonne Fairy, and Ernest "Mr. Clue" Shaw. (Courtesy of Ernest Shaw.)

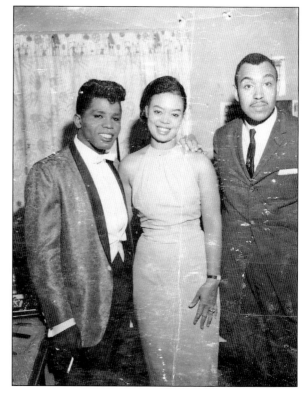

MARVA HICKS. A native of Petersburg, Hicks has gained national acclaim as a singer. In 1991, Polygram released her album entitled *Marva Hicks*. Her talents have also taken her to the big screen. She has appeared in *Asunder* (1998), and sang on film soundtracks for *The Brave Little Toaster Goes to Mars* (1998) and *Bodies, Rest, and Motion* (1993). She is pictured here in her senior year at Petersburg High School. (Courtesy of Petersburg High School.)

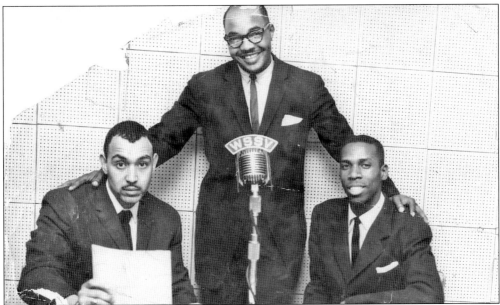

WSSV RADIO DISC JOCKEYS. From 1961 to 1967, Petersburg's WSSV, "The Station that Smiles for Miles," had three popular African American disc jockeys. From left to right, Ernest "Mr. Clue" Shaw covered sports, "Max the Player" (Frank Kennedy) played rock and roll and jazz, and "Vernon from Venus" (Vernon "Billy" Lee) played gospel. Their show aired from 7:00 p.m. to midnight from Monday to Saturday and was one of the most highly rated programs in the tri-city area. (Courtesy of Ernest Shaw.)

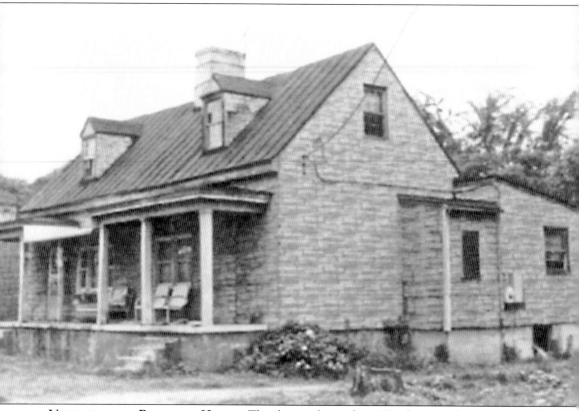

UNDERGROUND RAILROAD HOUSE. This house, located on Pocahontas Island at 213–215 Witton Street, was built during the first half of the 19th century and is still in existence. Although conclusive proof has not been found, the location is believed to have been a stop on the Underground Railroad during slavery. (Courtesy of the City of Petersburg.)

BIBLIOGRAPHY

Bushey, Mary Ellen, Ann Creighton-Zllar, Lucious Edwards Jr., L. Daniel Mouer, and Robin L. Ryder. *African Americans in Petersburg: Historic Contexts and Resources for Preservation Planning, Research and Interpretation.* Petersburg, 1994.

Carter, Linnie. *Strong Men and Women: The Series.* Richmond: Dominion Power, 2006.

Cooper, Susan. "Records of Civil War African American Troops Inspire Major Archival Project." *The Record,* 1996.

Dance, Martha Short. *Peabody High School: A History of the First Negro Public High School in Virginia.* New York: Carlton Press, Inc., 1976.

Durham, Suzanne K. Images of America: *Petersburg.* Charleston: Arcadia Publishing, 2003.

Hartzell, Lawrence Leroy. *Black Life in Petersburg, Virginia 1870–1902.* Dayton, OH: Duke University, 1983.

Jackson, Luther Porter. *Free Negro Labor and Property Holding in Virginia, 1830–1860.* New York: Russell and Russell, 1942.

———. *Negro Office Holders in Virginia 1865–1895.* Norfolk, VA: Guide Quality Press, 1945.

Kinard, Jeff. *The Battle of the Crater.* Abilene, TX: McWhiney Foundation Press, 1995.

Lancet. Petersburg: 1882.

Lardas, Mark. *African American Soldier in the Civil War USCT 1862–66.* Oxford: Osprey Publishing, 2006.

Peabody High School Alumni Association. *Peabody High School Centennial Calendar 1870–1970.* Petersburg: 2000.

Progress Index. Petersburg, 1960.

Richmond Times Dispatch. Richmond, 1960.

Smith, James W., Martha S. Dance, and L. R. Valentine Youth Group. *The History and Legend of Pocahontas Island.* Monograph, 1981.

Stephens, Travis. *Participation of Negro Troops in "the Battle of the Crater," July 30, 1864.* Thesis Submission, Virginia State College Department of History, October 1967.

Discover Thousands of Local History Books
Featuring Millions of Vintage Images

Arcadia Publishing, the leading local history publisher in the United States, is committed to making history accessible and meaningful through publishing books that celebrate and preserve the heritage of America's people and places.

Find more books like this at
www.arcadiapublishing.com

Search for your hometown history, your old stomping grounds, and even your favorite sports team.

Consistent with our mission to preserve history on a local level, this book was printed in South Carolina on American-made paper and manufactured entirely in the United States. Products carrying the accredited Forest Stewardship Council (FSC) label are printed on 100 percent FSC-certified paper.